D1238556

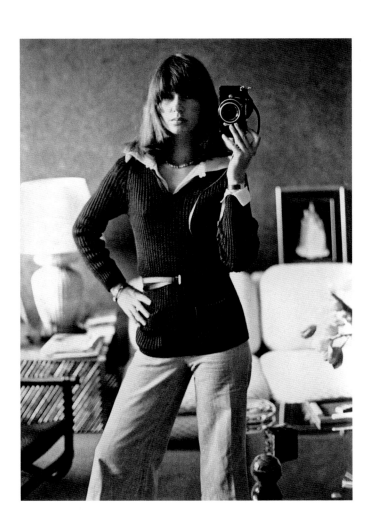

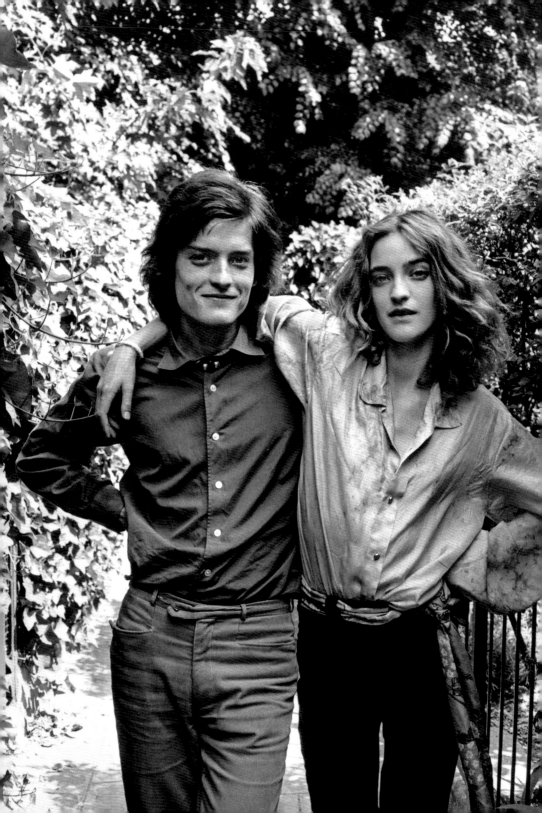

ENTRE NOUS

BOHEMIAN CHIC
IN THE 1960S AND 1970S
A PHOTO MEMOIR BY MARY RUSSELL

Edited by
Pierre Passebon

Flammarion

EXECUTIVE DIRECTOR
Suzanne Tise-Isoré
Style & Design Collection

EDITORIAL COORDINATION
Flora Chen

GRAPHIC DESIGN
Bernard Lagacé and Lysandre Le Cléac'h

INTERVIEW BY PIERRE PASSEBON
TRANSLATED FROM THE FRENCH BY
Barbara Mellor

COPYEDITING
Helen Downey

PROOFREADING
Lindsay Porter

PRODUCTION
Corinne Trovarelli

COLOR SEPARATION
Les Artisans du Regard, Paris

PRINTING
VeronaLibri, Italy

Simultaneously published in French as
*Entre nous, intimité du chic bohème des années 1960
et 1970, un photo-mémoire de Mary Russell*
© Flammarion S.A., Paris, 2019

English-language edition
© Flammarion S.A., Paris, 2019

All rights reserved. No part of this book may be
reproduced in any form or by any means, electronic,
photocopy, information retrieval system, or otherwise,
without written permission from Flammarion S.A.

Flammarion S.A.
87 Quai Panhard-et-Levassor
75647 Paris Cedex 13
editions.flammarion.com
styleetdesign-flammarion.com

19 20 21 3 2 1
ISBN: 978-2-08-020411-0
Legal Deposit: 11/2019

PAGE 1 Mary, by me.
PAGE 2 Newly arrived from London, Louise de la Falaise (not yet Loulou) with
her brother Alexis *chez moi* in Montparnasse, Villa Boulard, Paris, late 1960s.
She stayed with me until she met and moved in with Fernando Sanchez.
FACING PAGE On a shoot with Charlotte Rampling posing for Helmut Newton
for American *Vogue*, Cannes, 1970s.

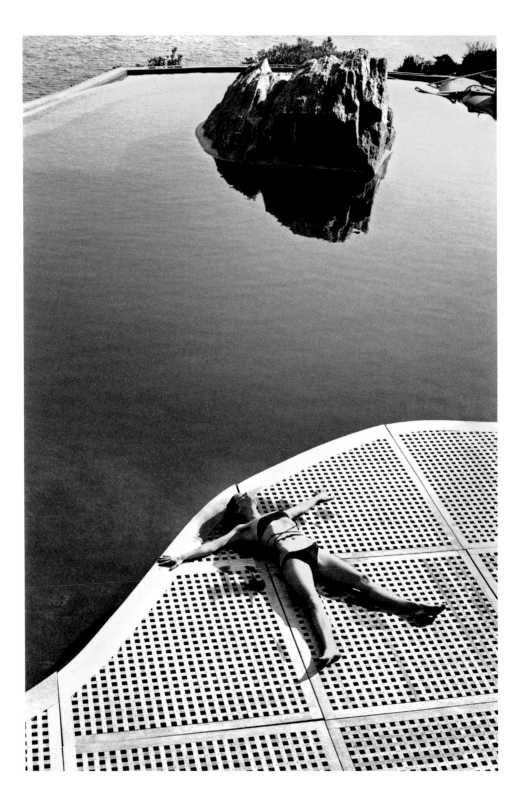

Interview with Mary Russell

PIERRE PASSEBON Your book is called *Entre Nous*.
Why did you decide on this title?

MARY RUSSELL *Entre Nous* sums up my personality and my life.
Your *Obsession* collection is very real for me, as I am an obsessive:
I have an obsession with beauty, with curiosity, and with freedom.
My sense of the artistic pushed me out of my family and made me
want to put a family together for myself, made up of people like me.
My upbringing was strict, with a naval officer father and a mercurial
mother in a small and puritan town north of Boston. I was a tomboy,
too tall, too skinny, too much of a rebel for a family who were terribly
"proper." Fortune smiled on me, and between New York and Paris
my new family came together. Being young and willowy, I wanted
to be a model. One of my mother's friends introduced me to Diana
Vreeland, editor-in-chief of *Vogue* in New York and high priestess
of fashion. For me Diana Vreeland was the perfect fairy godmother.
Generous and fun, she looked out for me all my life. She advised me
not to go into modeling, and catapulted me onto *Glamour* magazine
as an assistant, first in New York and later in Paris. She liked my
energy and my cheek, but above all she liked my French education.
When I was fourteen my father was posted to the South of France
(as an officer at the headquarters of the United States Sixth Fleet),
so I finished my schooling at a Catholic school before spending
two years at Les Arts Décoratifs (the School of Decorative Arts)
in Nice. I could speak French!

Miraculously, my father's life had taken a direction that set
the course for my own, a direction that was heaven-sent.
In some mysterious way I always seem to be in the right place
at the right time.

FACING PAGE, FROM LEFT TO RIGHT My mentor and idol Diana Vreeland
in Venice. Mary Quant on the King's Road, London, 1960s.

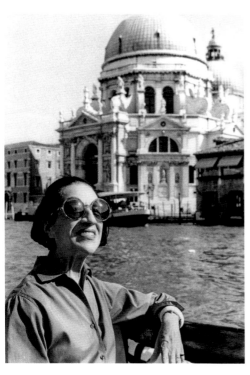

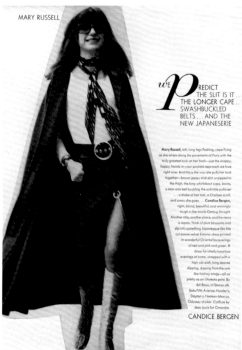

MARY RUSSELL

*we*P*REDICT
THE SLIT IS IT . . .
THE LONGER CAPE . .
SWASHBUCKLED
BELTS . . . AND THE
NEW JAPANESERIE

Mary Russell, left, long legs flashing, cape flying
as she whips along the pavements of Paris with the
truly greatest look on her back—just the snappy,
happy, hands-in-your-pockets approach we love
right now. And this is the way she pulls her look
together—brown jersey midi skirt unzipped to
the thigh, the long whirlabout cape, boots,
a man-size belt buckling the soft little pullover
. . . a shake of her hair, a Chelsea scarf,
and away she goes. . . . **Candice Bergen**,
right, blond, beautiful, and winningly
tough in the movie *Getting Straight*.
Another role, another place, and the news
is Japan. Think of plum blossoms and
slip into something Japanesque like this
cut panne velvet kimono-dress printed
in wonderful Oriental lacquerings
of red and pink and green. A
dress for utterly luxurious
evenings at home, wrapped with a
high obi sash, long sleeves
sloping, dipping from the arm
like folding wings—all as
pretty as an Unamato print. By
Bill Blass, of Staron silk.
Saks Fifth Avenue; Halzfer's,
Dayton's; Neiman-Marcus.
Odyssey choker. Coiffure by
Jean Louis for Cinandre.

CANDICE BERGEN

Thanks to this new adventure as junior fashion editor at *Glamour*, I met young photographers from Europe, like David Bailey and Jeanloup Sieff. My passion for photography was revealed. Being a spectator always suited me. Being behind a camera lens protects you and allows you to live out your fantasies at one remove. I adore taking photographs. It's an act of love and a game of seduction. I feel like Diana the Huntress, pursuing beauty and capturing it. At that time, working for *Vogue* was a passport to international travel. It opened every door, easily. My new job was a delight.

In New York, the coterie around Andy Warhol became my family. Diana adored him, which was seen as risqué at a time when we were just emerging from the strict conventions of the 1950s. In some people's eyes, being close to Warhol was outrageous. Lunch at the Factory every day was always a new adventure, a mixture of socialites, artists, and rogues!

In the 1960s, Alex Liberman, the big shot at Condé Nast, predicted the new surge of energy among fashion designers in Paris. Since I spoke French, I was his natural choice to open a new *Glamour* office on place du Palais Bourbon. The pay was paltry but it was prestigious (or so I was told). *"Pour la gloire!"* he would always say to me. My job was to approach and charm all the young designers who were just starting out. We'd be out every night. Like Paris in the 1920s, Paris in the 1960s was rich in improbable encounters. Social barriers had been cast to the winds, for the night at least, I met Yves Saint Laurent; a *coup de foudre*! My family was expanding. We would meet up at Yves' place on place Vauban, just like we used to at Andy's.

Diana Vreeland, my guardian angel, made me editor of American *Vogue* in Paris. Encouraged by my experiences with the great photographers who worked for the magazine, such as Helmut Newton, Henry Clarke, and Guy Bourdin, I bought my first Nikon, and from behind the safety of my lens began surreptitiously observing life at every moment. To my great delight, it was a revelation.

Entre Nous is the fabric woven from all these moments, captured as I encountered them, through my obsessions and my sleepless nights.

I invite you to share them with me.

FACING PAGE, FROM LEFT TO RIGHT Sitting on the corner of a desk when I was a *Vogue* correspondent in Paris, dressed in Missoni. Strolling the streets of Paris, *Vogue* New York, 1970.

I didn't Sleep for
Twenty Years

Let me lead you through the extraordinary days of the 1960s
and 1970s, an incredible time when we thought we would never
grow old. The world was made just of us, a curated group
of friends coming of age in Paris: artists, designers, lovers of beauty,
and lovers of love. We shook free the constraints of our backgrounds
and reveled in the possibilities of a life beyond our wildest dreams.
We were brand new and had everything ahead of us. Little did we
know that we were living an adventure now looked back upon as
a pivotal juncture of the twentieth century. Fresh off the boat, having
literally crossed the Atlantic on a Greek tramp steamer, I rented
the studio of sculptor César in the 13th arrondissement with my little
girl in hand, my marriage didn't survive the move to Paris. Brace
yourself for some serious name dropping; I was always attracted
to beauty, artistic talent, fame, and fortune.

It was as if the universe had destined us all to meet. The 1960s
explosion was in full swing on both sides of the Atlantic. Andy
Warhol was in Paris, Yves Saint Laurent was on rue Spontini shaping
denim and safari looks for his first ready-to-wear collections,
Nureyev was living *chez* Jimmy Douglas, and Loulou de la Falaise
was *chez moi,* pre-Yves Saint Laurent. Antonio Lopez and many
artist friends from New York were living in Saint-Germain-des-Prés
near the Café de Flore, our mecca, where we met every evening
to plot and plan endless nights spent roaming and combing
for adventure.

FACING PAGE At the Lido in Venice. During the Venice Film Festival in the early
1970s, Giovanni Volpi invited socialites, models, movie stars, artists, and a few
parvenus to his cabana on the Lido for delicious picnics *all'Italiana,* prepared
and delivered from across the lagoon from *Palazzo* Volpi on the Grand Canal
by private *motoscafo,* served by liveried retainers *al fresco.* From left: Giovanni
Volpi, Paloma Picasso, Thadée Klossowski, Mary Russell, Hélène Rochas.

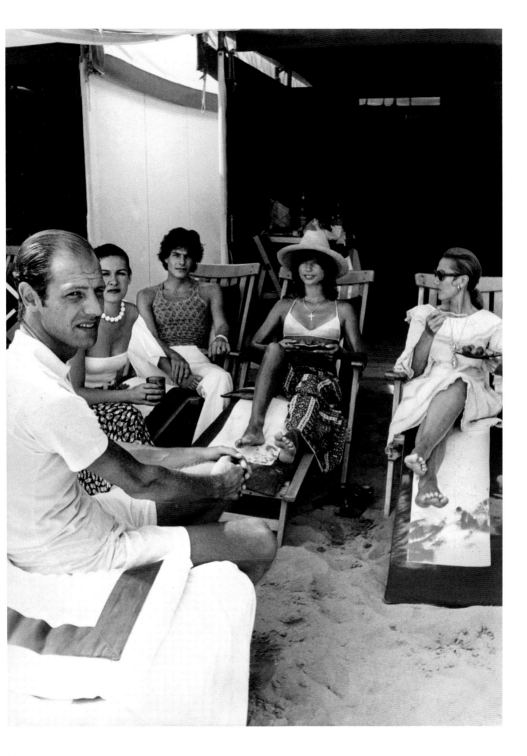

ABOVE Morning on the port in front of the Café Sénéquier, Saint-Tropez, in the mid-1960s. *Moi* barefoot riding on the back of Gunter Sachs' motorcycle. He called me *La Girafe*, loved my short-haired, skinny-boy look and my uniform of white tee shirt and jeans, a far cry from the long-blond-haired German models he usually preferred. Somewhere out there is a movie he made that summer called *Les Girafes de Saint-Tropez*.

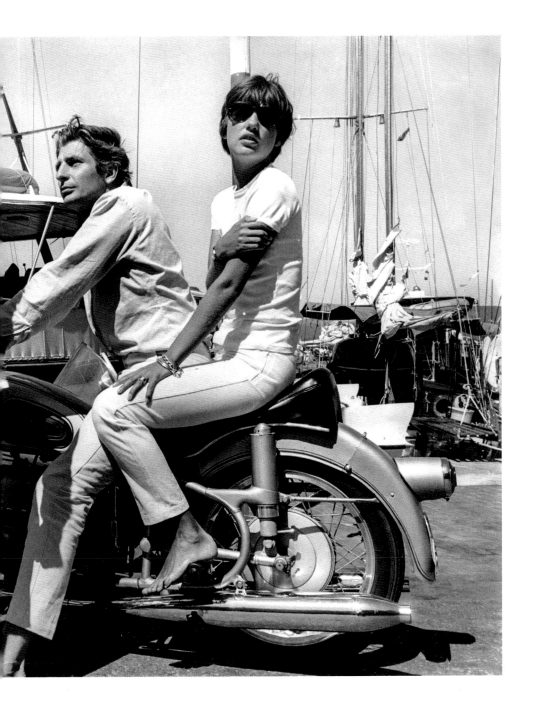

From Saint-Tropez
to the Lido in Venice

It was the summer of 1965 and I was off to Saint-Tropez, to Club 55 on Pampelonne beach, where I rented a tiny hut for a hundred dollars a month. Every morning, Gunter Sachs would zoom to my beach on his Riva motorboat, which he dubbed *"le bateau de onze heures"* (the eleven o'clock boat), accompanied by a brace of bikini-clad, champagne-drinking models, dancing to the strumming of a trio of Mexican guitarists.

Hopping aboard, we would speed to the port for breakfast *chez* Sénéquier, then afterward we would retreat to Villa Capilla, Gunter's idyllic beach palace, to play and to bask in the dappled sunlight all afternoon.

September found us in Venice for the film festival. With his Grand Canal *palazzo* as a base, Giovanni Volpi became our social director, hosting lavish balls and glamorous picnics at his cabana on the Lido. There, movie stars mingled with an aristocratic A-list, as well as artists, models, hangers-on, and various denizens of fashion.

FACING PAGE On the mats at the Lido in Giovanni's cabana.

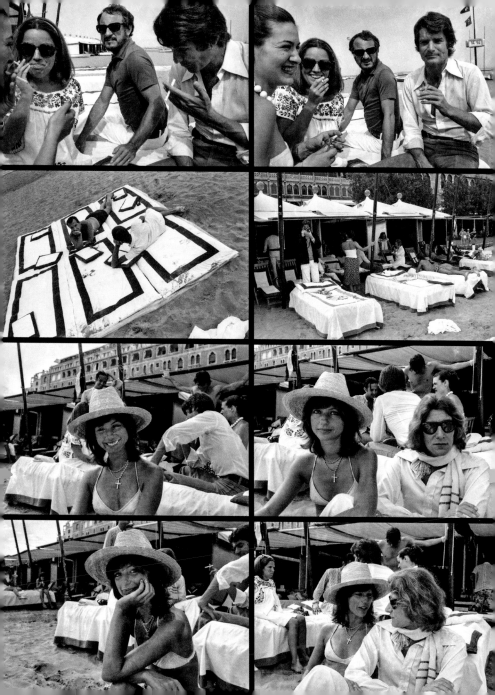

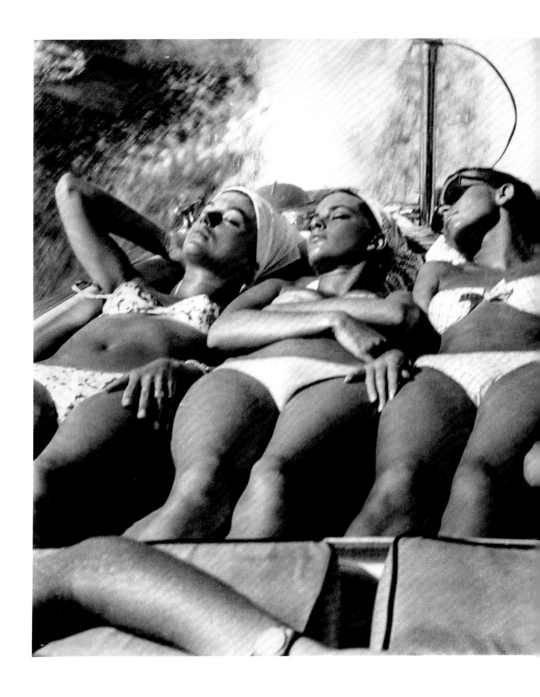

ABOVE In Saint-Tropez on Gunter Sachs' Riva, on our way to Pampelonne beach. I'm on the left, Serge Marquand on the right with a couple of models sandwiched in between.

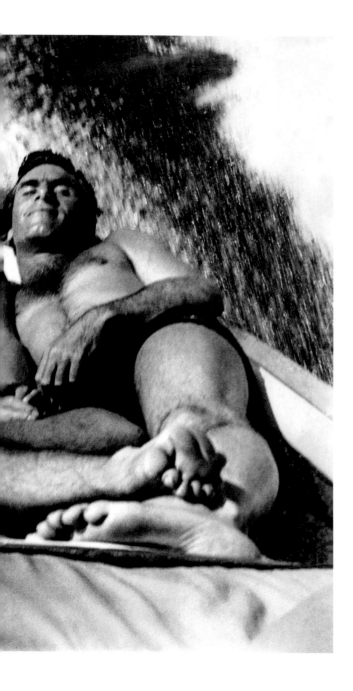

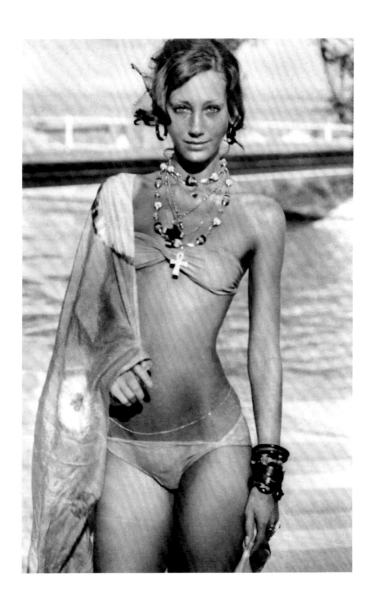

ABOVE Marisa Berenson on the Lido during the Venice Film Festival,
early 1970s, decked out in hippie luxe, piled-on *bijoux*, tie-dyed sarong.
FACING PAGE Marisa gracing the Volpi cabana beach mats.
Jacques Grange, and François-Marie Banier in the Volpi's boat.

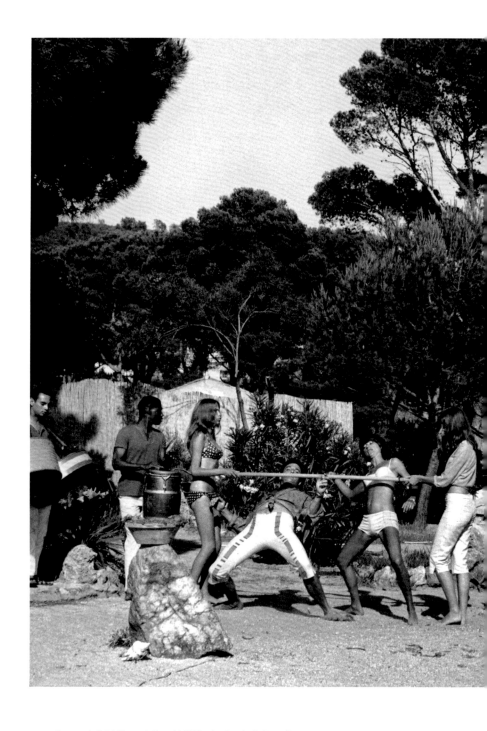

ABOVE Summer in Saint-Tropez in the mid-1960s, dancing the limbo at Gunter
Sachs' beach house on Pampelonne beach. Every afternoon he would host
a three-hour lunch, inviting various and sundry beauties, old retainer playboy pals,
and new additions picked up at nightclubs the night before.

Photographers
and Artists

Aged ten, I loved spying through the lens of my first camera, a box Brownie, and surreptitiously capturing images of everything that struck me. I devoured art books and fashion magazines, inhabiting a dream world as the heroine of a movie all my own. Living in the South of France as a teenager while enrolled at Les Arts Décoratifs in Nice, I meandered along the streets where Matisse once walked, and reveled in Van Gogh's landscapes in Provence. Channeling Cézanne, I viewed Mount Sainte-Victoire near Aix-en-Provence from every possible angle. Then it was off to Spain to see the Prado in Madrid for its Velázquez and Goya paintings, and to Barcelona for Gaudí and his Sagrada Família. Then Italy for more museums, and basilicas, where I fell in love with Michelangelo's *David*. Peggy Guggenheim took me through her *palazzo* in Venice, where I marveled at her remarkable art collection.

As an editor-at-large and photo stylist for *Glamour*, and then *Vogue*, I oversaw the conceptual development and execution of shoots, from casting and location to actual styling. I could not have dreamed of better on-the-job creative training, as this allowed me to work with all the top photographers and artists of the period. Climbing the stairs on rue Aubriot in the Marais to Helmut Newton's studio, I spent hours painstakingly preparing for even the simplest photograph, developing patience and perfectionism under his demanding eye.

Though the images we crafted were often sulfurous, Helmut was deferential and respectful of the models. He encouraged my photography and loved hamming it up as he allowed me to snap him, generously teaching me his tricks of the trade. He commanded total authority, fueled by his dark humor and fetishistic vision. I worshipped him.

FACING PAGE My favorite photographer and mentor Helmut Newton liked posing for photos as much as he loved taking them. Here, while on location in Cannes for *Vogue*, he hoots it up on the Croisette with model Gunilla Lindblad.
PAGES 23–24 We did many shoots for *Vogue* with Charlotte Rampling, one of Helmut's favorite subjects. We would rehearse fantasy scenarios, then he'd quickly shoot only a few rolls of 35-mm film. He would say: "Every click [never a motorized camera] counts. Each image on a contact sheet is a finished picture. Think Henri Cartier-Bresson." Here, he works with just one assistant.

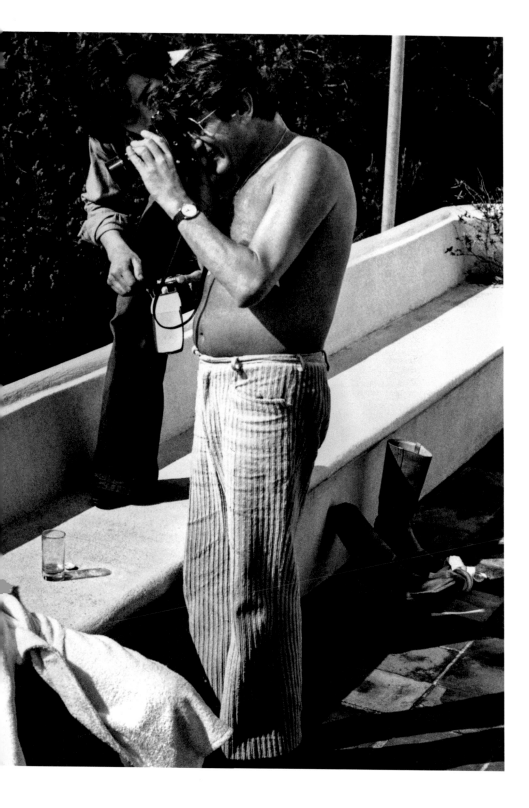

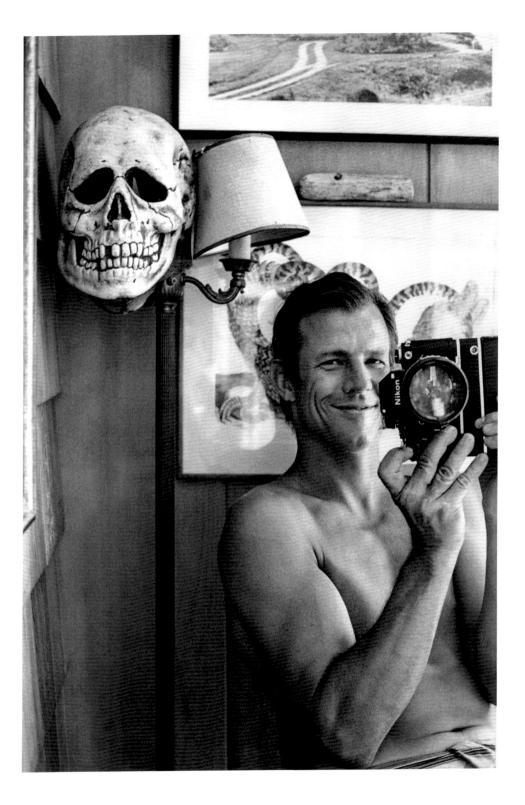

Ever parsimonious, after a *Vogue* shoot for which Jerry Hall, her nails painted his favorite blood-red, clutched a slab of meat to her head, Helmut cooked and served the same steak for dinner that very night to Alex Liberman, the steaming cut of beef speared by those fetish fake nails!

As I made my way through this rarefied world, I met and photographed many artists. The world was smaller then; there were no paparazzi, just a few fellow photographers along the runways when designers showed their collections. It was more a fraternity than a feeding frenzy.

We bonded as artists do in Paris, seeing, hearing, feeling, touching, and tasting a privileged existence *en famille*. Work was play, and play was everything. We were the most entitled of children, lost in beauty, pleasure, daring, and adventure.

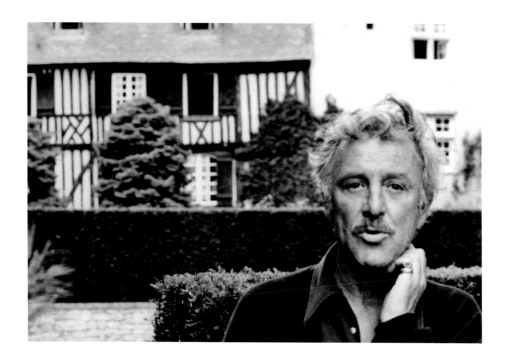

FACING PAGE Peter Beard, one of my favorite men of all time, was movie-star handsome, a madcap, sandal-clad hippie from an uptight background like mine. He was also a brilliant artist, photographer, adventurer, and seducer of every human being and animal in existence. I enjoyed star-studded weekends at his mill on the cliffs at Montauk during the 1970s.
ABOVE I loved working with Henry Clarke, one of *Vogue's* most enduring, endearing photographers. He was a perfect gentleman, and outlasted most of the hip photographers of the 1960s and 1970s with his classic style. Here, on location in Normandy *chez* Marie-Hélène de Rothschild.

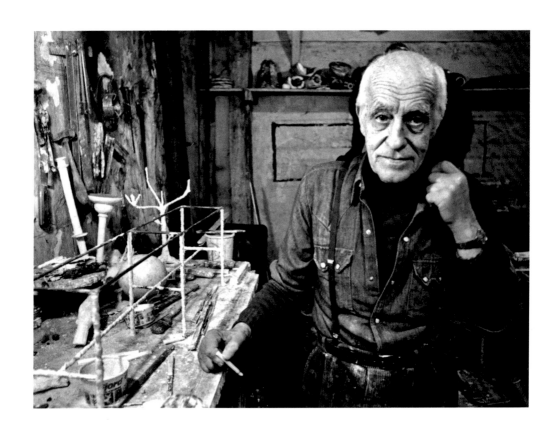

ABOVE I had the great privilege of photographing Diego Giacometti at his
Montparnasse studio, watching him as he created his unique metal sculpted
furniture. For this portrait he wears his pet cat around his neck, Paris, early 1970s.
FACING PAGE David Hockney had an important exhibition at the Louvre in 1974.
He lived near me in Saint-Germain-des-Prés, and was part of *la famille* for
a few years, often turning up for coffee at the Flore or late nights at Le Sept.

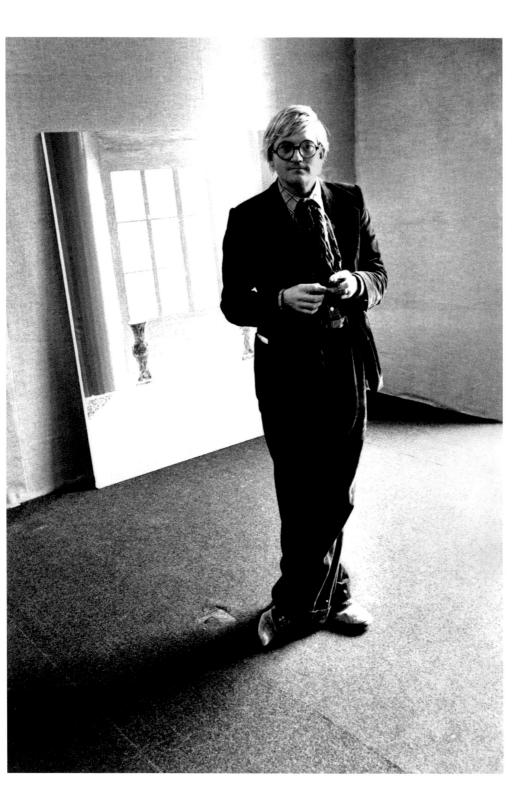

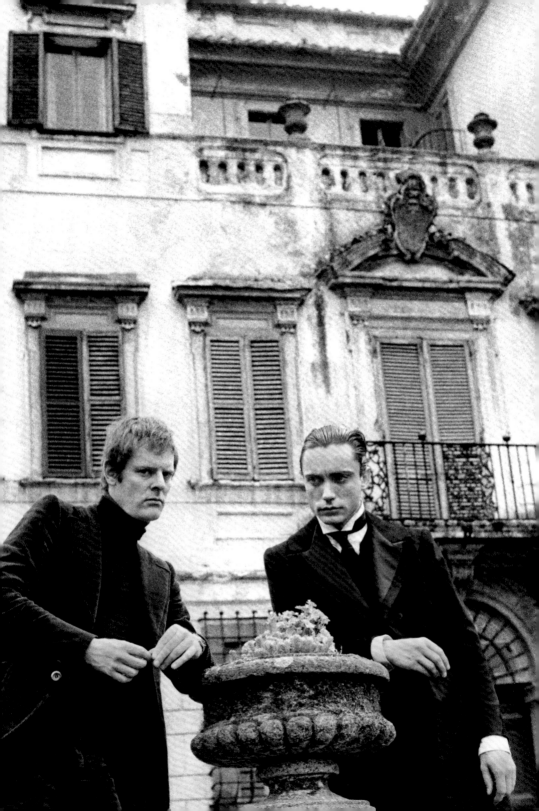

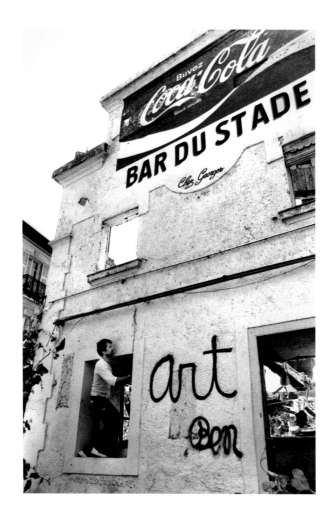

FACING PAGE While on assignment in Rome in 1974, I visited Paul Morrissey and Udo Keir on the set of *Andy Warhol's Frankenstein*. Morrissey was a very important element of the Warhol tribe, directing most of his iconic films.
ABOVE In the late 1970s I followed the artist Ben all around Nice, where he jumped onto buildings impromptu, to create what may have been the first wall art, pre-grafitti. He was one of the École de Nice artists connected to Les Arts Décoratifs, where I went to school.
PAGES 32-33 On location for *Vogue* in the late 1970s, with legendary photographer Francesco Scavullo on the beach at East Hampton, his partner and producer Sean Byrnes in the background keeping a sharp eye on things.

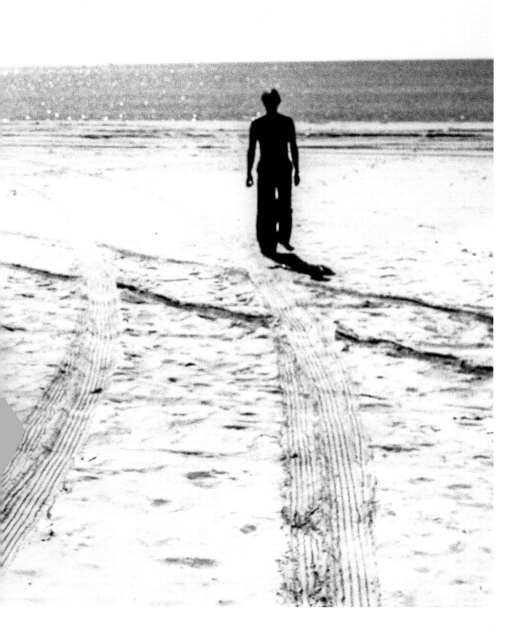

Andy in Paris

There was no one like Andy Warhol. We had become fast friends in New York and I knew him well. His weird, wigged demeanor hid a shy boy from Pittsburgh, eager to escape his hometown and immerse himself in a brand-new life in Manhattan, where he readily savored everything strange, different, and forbidden.

Andy disliked his looks and was socially awkward. He surrounded himself with outlandish dream characters plucked from all walks of society—a clutch of wannabes; rich, social outcasts; penniless, good-looking opportunists; and would-be artists. The Factory was a big, shabby space downtown. It became a gathering place where lunches were catch-as-catch-can: we all vied for invitations so we could bask in Andy's mysterious aura, titillated by a sensation of the delicious danger that surrounded him.

Like many photographers, including Helmut Newton and myself, Warhol preferred peering through a camera lens to actually speaking as his way of communicating. He captured all manner of subjects with both his small and gigantic, phallic Polaroid cameras. We adored his paintings of Campbell's soup cans and were fascinated by his overly long films like *Empire*. Basking in the atmosphere of the Factory was a brand new, exciting—almost daring—experience, rife with in-your-face unusual characters and simmering homosexuality proudly paraded by beautiful young men. Andy was a rare breed, asexual, but a true romantic, falling in love with everyone he met. "Oh gee!" was his authentic reaction when coming face to face with someone famous or infamous. He courted fame, the jet set, high and low society, never losing his wide-eyed, childlike awe while confronting the trappings of luxury or decadence.

FACING PAGE Andy liked to lunch at Brasserie Lipp in Paris, here with Shirley Goldfarb and a friend in the late 1960s.
PAGES 36–37 A contact sheet of Andy, Edie Sedgwick, and several members of the Factory frolicking in and out of the bathtub at the Hotel de Bourgogne in Paris during their first trip to Paris in the 1960s. It looks as if Andy is not wearing his ubiquitous wig, or else it's a short-cut version.

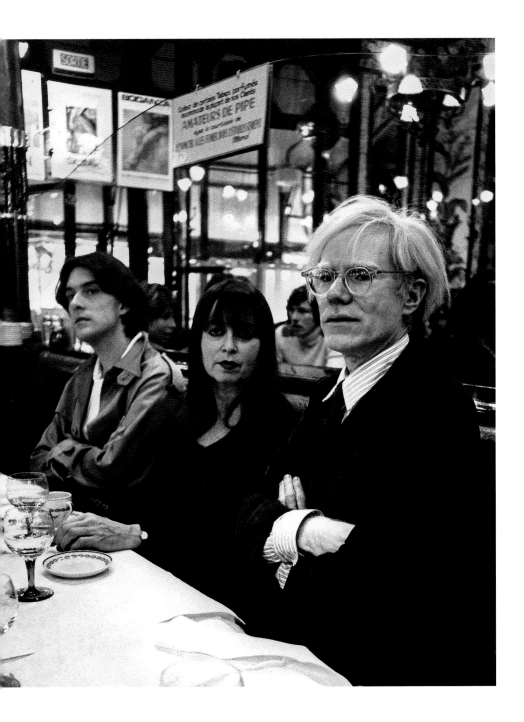

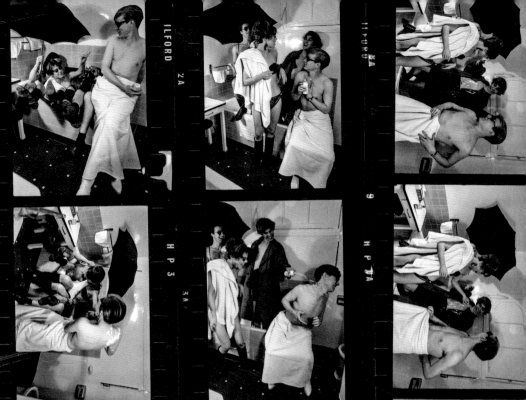
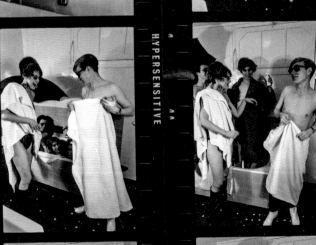
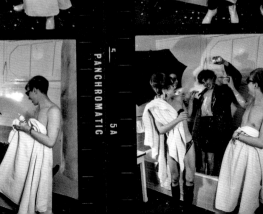
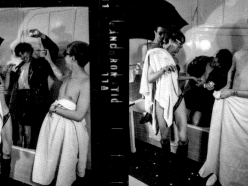

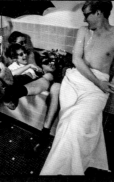
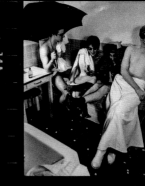

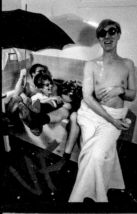

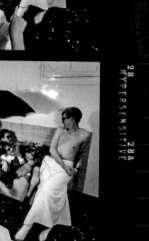

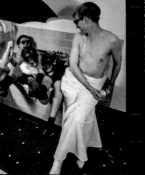

ILFORD 14A ILFORD 15 HP 3 15A 16 HYPERSENSITIVE 16A 17 PANCHROMATIC 17A

ILFORD 27 HP 3 27A 28 28A HYPERSENSITIVE 28A 29 PANCHROMATIC

Arriving in Paris with Edie Sedgwick and a gang from the Factory for the first time at the end of the 1960s, Warhol stayed at the Hotel de Bourgogne near the place du Palais Bourbon. On his next trip, with his protector and business agent, Fred Hughes, he drummed up some serious business, meeting and selling large Polaroid colored paintings to well-heeled Parisian socialites. We welcomed them into our Saint Laurent/Bergé family. Andy immediately created the iconic portrait of Yves that hangs in the avenue Marceau couture house to this day. Many were our long lunches at Brasserie Lipp, after which we would lounge in his apartment on the rue du Cherche-Midi. Invitations-only (plus a few hangers-on) were organized by Fred, a chic, smooth operator from Texas. Charming, impeccably dressed, a divine dancer and *charmeur*, he effortlessly fronted Andy as they navigated the worlds of European art and society.

FACING PAGE Andy, being shy, hid behind his camera, but was one of the first
to understand the power of publicity and allowed a few of us to take his picture.
PAGES 40–41 A rare contact sheet of Warhol and members of the Factory
38 in their room at the Hotel de Bourgogne in Paris in the 1960s.

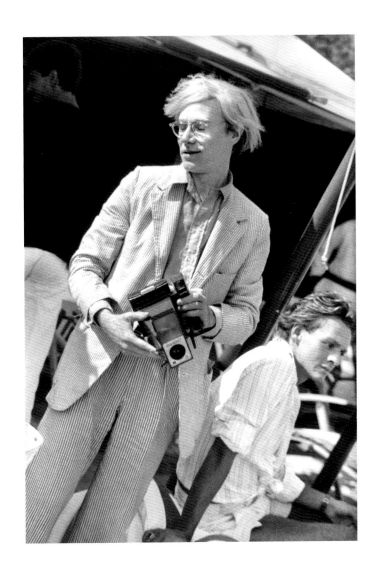

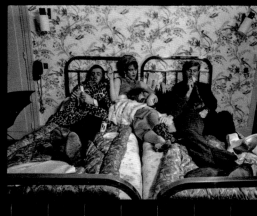
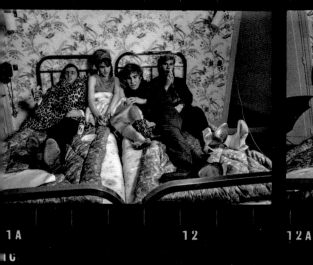

1 A 12 1 2 A 13
1 C

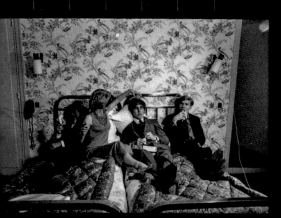

5 A 6 6 A 7
T I C

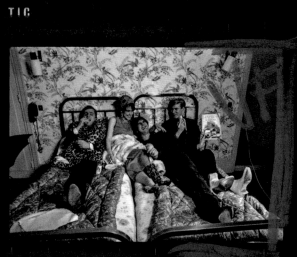
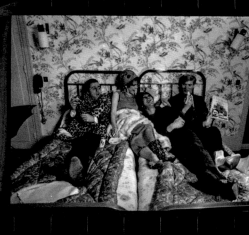

2 3 A 24 2 4 A 25

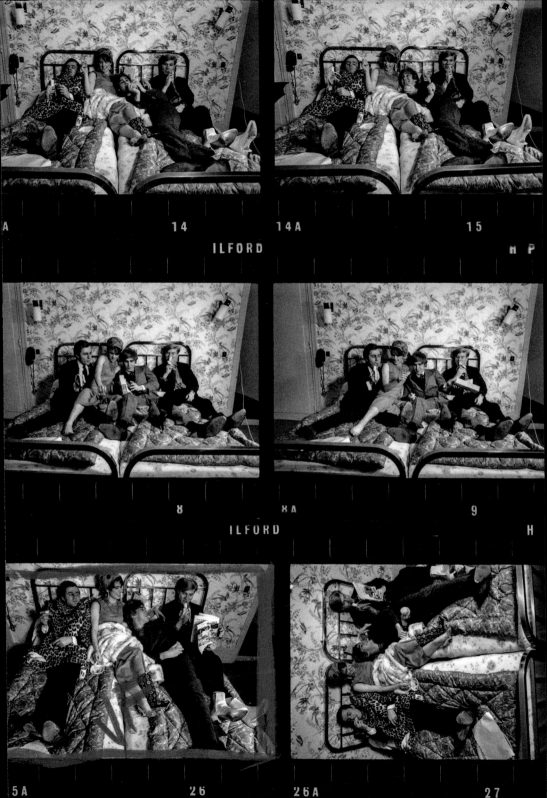

ABOVE Silvia Miles and Joe D'Alessandro on the Lido in Venice.
FACING PAGE One of my favorite photos: Dalila Di Lazzarro in Rome
on the set of *Andy Warhol's Frankenstein*.

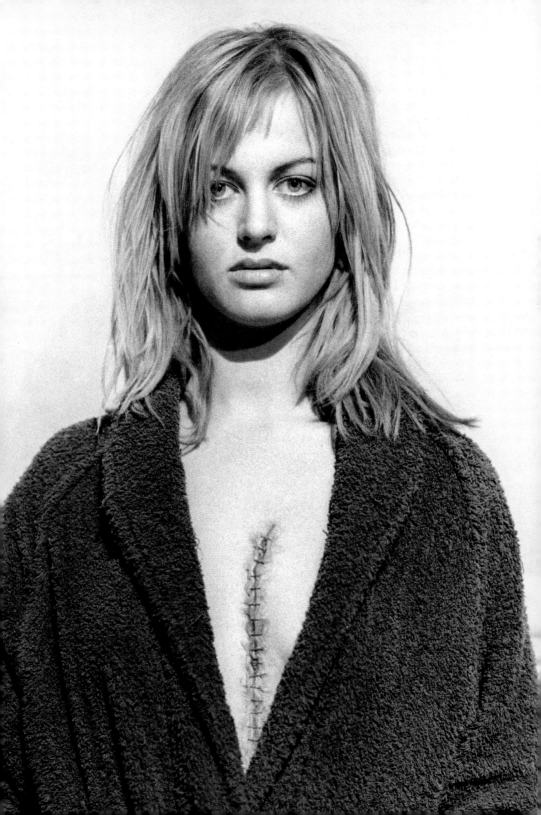

ABOVE Fred Hughes, the man behind Andy Warhol's first commercial endeavors. Born in Texas, he made himself invaluable to Andy as producer and business manager. He wrangled the master and his unruly clan while drumming up orders for Warhol portraits, both in Paris and worldwide. Fred dined and danced the "ladies," making sure that Warhol and co. were invited to the "in" parties.

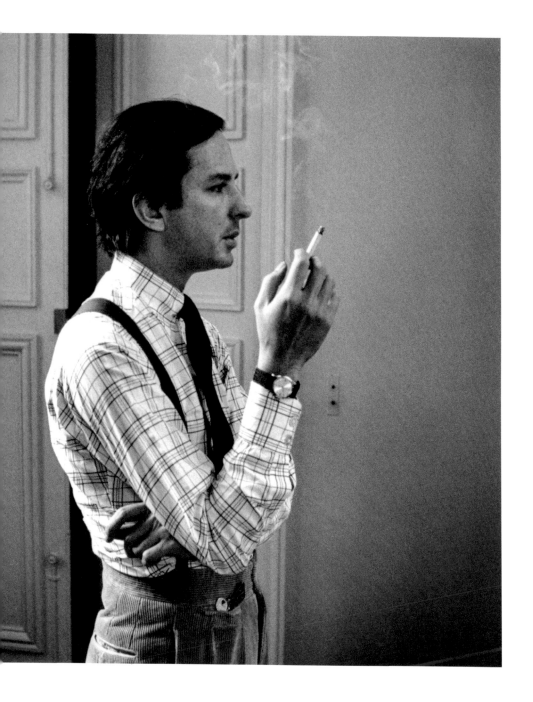

Bohemian Chic

The images of bohemian chic remain forever iconic: Flower Power, retro, vintage, mods, punk rockers, James Dean and Marlon Brando, Woodstock and Warhol, the King's Road and the Sex Pistols, Jimi Hendrix, Lou Reed, Paul Morrissey, the Stones, Birkin and Gainsbourg. *Mai soixante-huit*—the May 1968 student uprising in Paris where we manned the barricades—will forever be engraved in my mind as a major turning point.

All of a sudden fashion was turned upside down: from fashion designers Mainbocher and Galanos in the USA to Courrèges, Paco Rabanne, and Yves Saint Laurent in Paris; and from Hardy Amies to Mary Quant, Zandra Rhodes, and Vivienne Westwood in London.

Mademoiselle Chanel was fuming!

"Live fast, die young" was our motto, rebellion was our *art de vivre* as we hurtled headlong into the intoxicating unknown. Removing ourselves from the prescribed social order and the mannered mores of the 1950s, we catapulted toward what was to become a total political, cultural, and artistic revolution of the kind not seen since the Roaring Twenties.

Spurred by the political upheaval of the 1960s, four hundred thousand hippies congregated on muddy fields near Woodstock, New York, in 1969 for a music festival that catalyzed the Age of Aquarius. We wouldn't have missed it for anything. It was here that our insurrection came to life, fueled by groundbreaking music played by artists of all races, men dressed in gorgeous, romantic outfits, bedecked with piles of ethnic jewelry. They were adulated by adoring, screaming fans, many nude, others wrapped in colorful peasant skirts, fringed leather jackets, beaded macramé vests, and mixes of thrift shop finds, their flower-filled tresses wrapped with colorful headbands. The crowd shared joints and each other in a gigantic love-in—ushering in an era of thrilling sexual freedom.

FACING PAGE Strolling the streets of Saint-Tropez: Florence Grinda with Marisa Berenson sporting Lothar's Berber blue cotton separates.

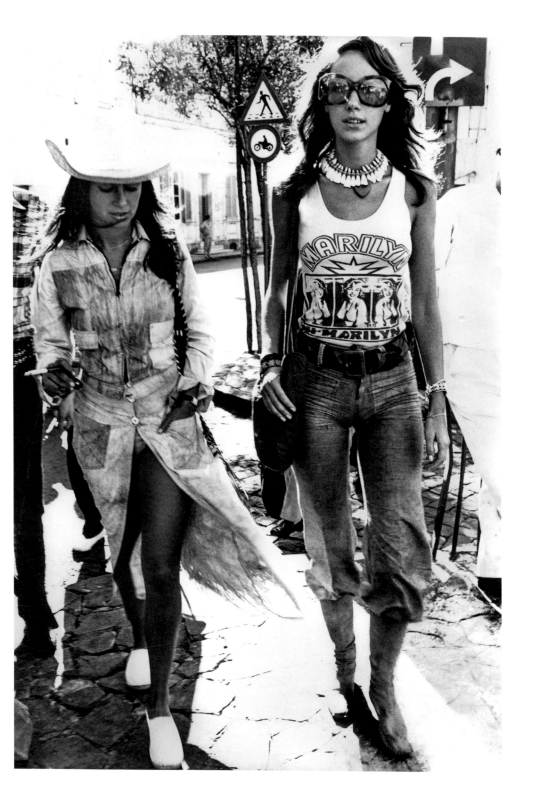

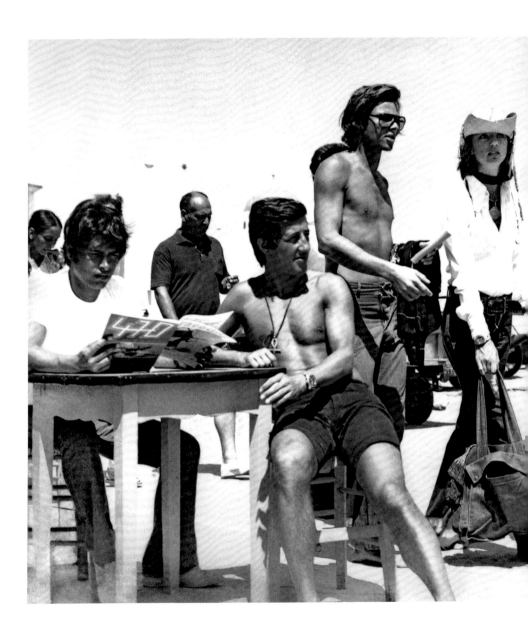

ABOVE We loved our cowboy hats and bell bottoms. On the quay in Mykonos where I spent a romantic weekend with the divine Hiram Keller.

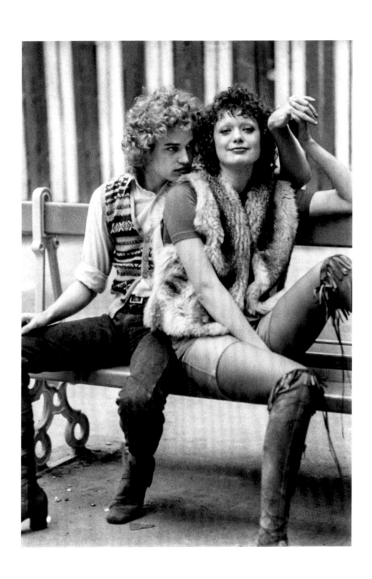

ABOVE Jay Johnson and model friend in perfect 1970s mode.
FACING PAGE We made our own hippie necklaces with stones and
leather to wear with ethnic thrift shop finds.

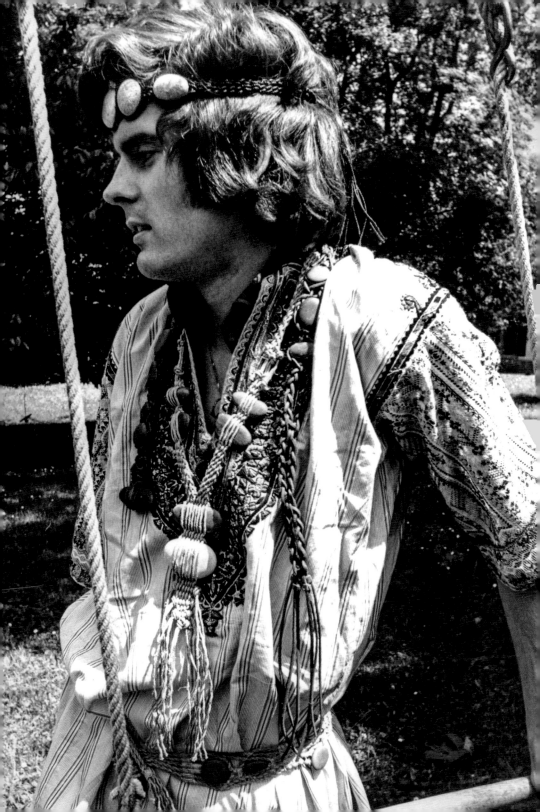

The British music invasion and the rabid fandom of the Beatles and the Rolling Stones already held much of the world's youth in thrall. Across the Channel, in England, London's East End photographers David Bailey, Terence Donovan, and Brian Duffy occupied the socially stratified, hallowed halls of Vogue House in Hanover Square, shocking the uptight editors with their Cockney accents and contributing to the breakdown of the British class system. Then along came Mick Jagger and Jim Morrison, sinuously strutting the stage in skintight velvet bell bottoms, body-clinging silk shirts, and kinky black leather, seducing every human within sight and sound.

In Paris, Yves Saint Laurent was reinventing fashion, breaking all the rules as he put his imprimatur on lowly navy blue denim by designing sexy separates in this common fabric for his brand-new Saint Laurent Rive Gauche ready-to-wear collection. Blue jeans were worn mostly by workmen and were light years away from the universal jeans uniform of today.

Once in a while Yves would escape to Marrakesh, far from the world of haute couture, reminding him of his North African birthplace in Oran, Algeria. There, he let loose and played with friends while creating his own version of hippie chic. He wore loose djellabas and harem pants, later adapting them into his collections. He designed khaki "safari" and ethnic pieces for both men and women. Unisex was born.

We made entrances all over Paris in our lace-up safari tunics, studded belts slung low on the hips, wearing high boots. The staid Paris bourgeoisie was shocked to see us sporting Yves's chic pantsuits at upscale restaurants where pants worn by women were forbidden, or showing up at black tie parties wearing his tuxedo pantsuits.

In Milan, Giorgio Armani perfected menswear for women, and Gianni Versace gave us chic, fetish black leather and chain mail. Fiorucci was our go-to boutique for hip frippery.

London was in full, eccentric bliss. Malcom McLaren and Vivienne Westwood opened their SEX boutique on the King's Road. Vidal Sassoon hair cut my hair in his signature geometric style, to match that of my idol, Mary Quant.

Summers in Saint-Trop included shopping expeditions to Lothar's for authentic, tie-dyed cotton Berber blue separates, then to Choses for the best white jeans, and Mic Mac for sensual flowing dresses to wear club-hopping. We reveled in those endless days and nights, never thinking they would end.

FACING PAGE At Fernando Sanchez's apartment, place de Furstemberg, one of our favorite hang-outs. Loulou is wearing an ethnic-chic mirrored Indian vest and tie-dyed blouse. Fernando wears a Mao-neck tunic. Fernando was the catalyst for Loulou's karmic meeting with Yves and Pierre.

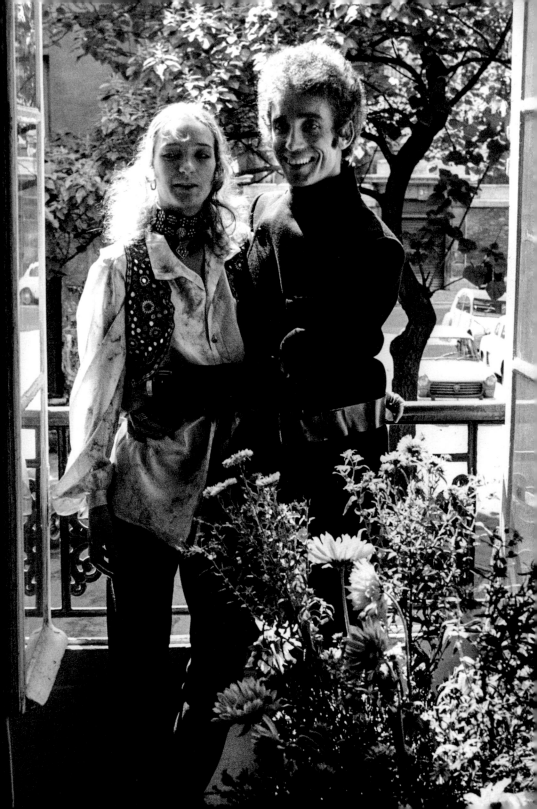

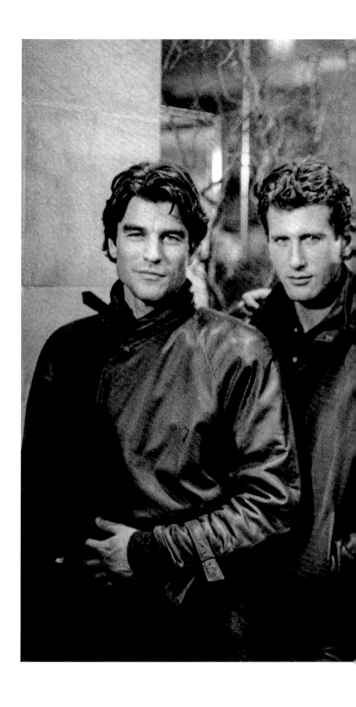

ABOVE Gianni Versace and his boys all wearing his sexy black leathers as a true fashion statement. His first menswear collections were inspired by his cinematic fantasy heroes: Pasolini, Marlon Brando (*On the Waterfront*), James Dean (*Rebel Without a Cause*). He gave me one of these bomber jackets and a slinky chain-mail dress from his women's collection. I loved dressing as a boy… then as a girl.

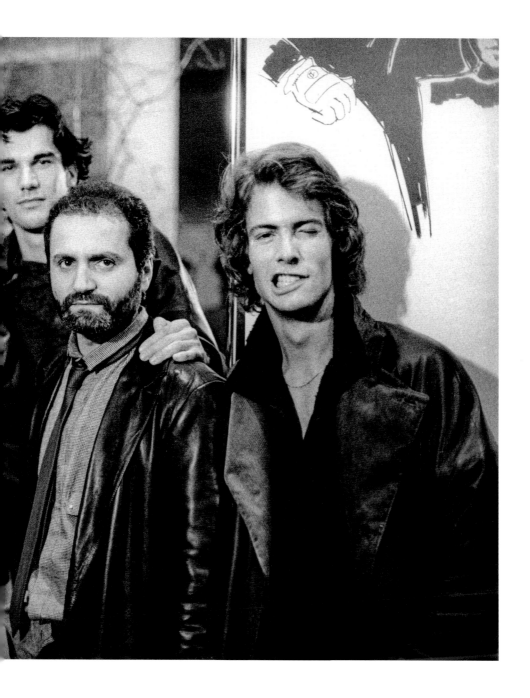

Artists and Influencers

It's hard to imagine how small and codified the world of fashion still was when I arrived in Paris in the mid-1960s to open the magazine *Glamour*. The French Condé Nast magazines were housed in an elegant building on the place du Palais-Bourbon. It all felt rather grand, even intimidating, considering the disdain that met me: to the French employees, I was an American interloper. They relegated me to a ground-floor space out of sight, next to the mail room. It didn't take me long to pull the place together, buying some chic basics from the Bazar de l'Hôtel de Ville (BHV). Within a week, I managed to put a unique stamp on my turf. Imagine the faces of the stuffy French *Vogue* editors peering down from their upper-floor offices as they witnessed Andy Warhol and Edie Sedgwick entering my humble *Glamour* Paris quarters. Finally, I was accorded a modicum of respect. Now, when they tried to get my attention, I could pretend not to see *them*....

At the end of most days I would meet Antonio Lopez and other artist friends from New York and Paris at the Café de Flore in Saint-Germain-des-Prés. Here is where anyone and everyone in our world of fashion would hang out. We adored Sonia Rykiel, whose boutique, Laura, was far away on the avenue du Général Leclerc in the 14th arrondissement, where I would trek with my editor pals from *Elle* to snap up her sexy knits.

Karl Lagerfeld, who at that time was designing for Chloé, also had us enthralled. At Karl's mezzanine bachelor pad on the place Saint-Sulpice, every night was an open house. He adored surrounding himself with talented friends and hangers-on, to drink in their energy. For, at heart, Karl was a loner. Always very generous, he plied everyone with gifts, food, and drink. He was an obsessive collector of art, books, objects, and people. Then, as if on cue, a certain Jacques de Bascher appeared on the scene with his brother Xavier. Bearing a title from an obscure Breton fief, he held court at the Flore. Movie-star handsome and dressed to the dandified nines, Jacques played it for all it was worth. A fierce and ambitious operator, de Bascher navigated like a pro, his calculating eye on the prize. It didn't take Karl long to notice him and, in an instant, adopt him.

FACING PAGE Antonio Lopez, fashion illustrator extraordinaire, collector of beauty. His lush fashion illustrations executed for *Vogue* and other publications record better than any other, before or since, the look and glamorous lifestyle of those days. He painted all he discovered, lived, and loved. Here with Jacques de Bascher and *moi* as I pose for his Polaroid camera.

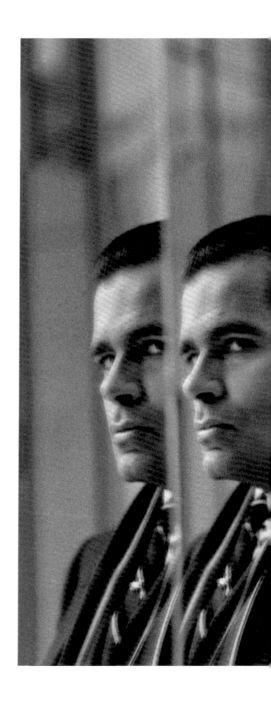

ABOVE Karl Lagerfeld without dark glasses! So handsome, a brilliant, funny conversationalist, generous to a fault (though he would never admit to any faults!), Karl was an integral, outgoing member of *la famille* before fame and cruel Paris intrigue began to separate him from most forms of intimacy. I took this portrait in his bathroom at his bachelor pad, place Saint-Sulpice, in the early 1960s.

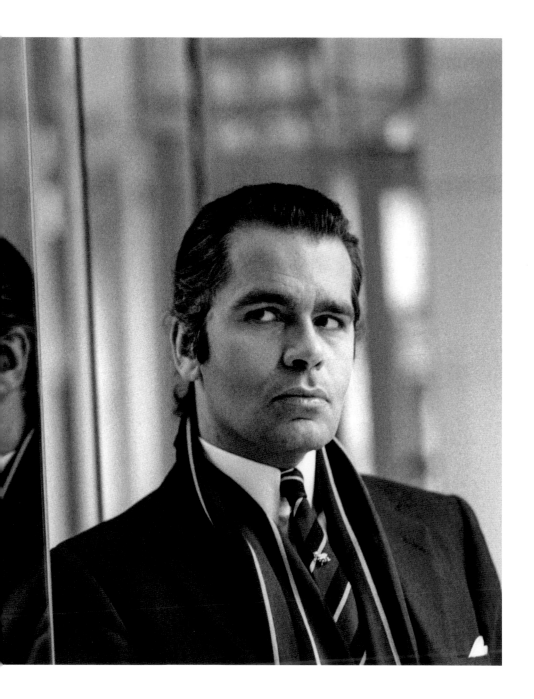

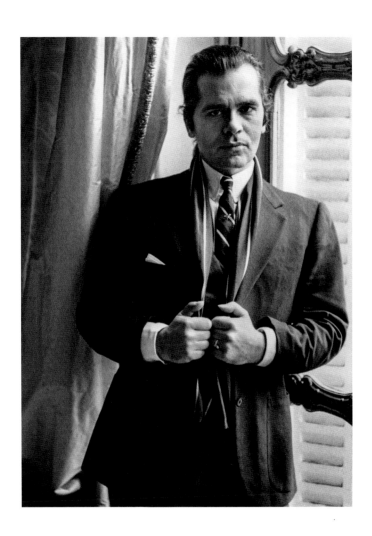

FACING PAGE AND ABOVE Karl, after a successful stint at Chloé, began designing for the
Fendi sisters in Rome, then was recruited by the slumbering house of Chanel to
reinvigorate the brand. He brazenly reinterpreted the venerable designs of Mademoiselle,
shocking the fashion world with his almost comic versions of Chanel's classic looks.
The new Karl was born. He lost weight, donned sunglasses, black jeans, gloves, and boots.
His white shirt collars got higher, and he powdered his white pony tail, creating
the Karl Lagerfeld persona we know today.

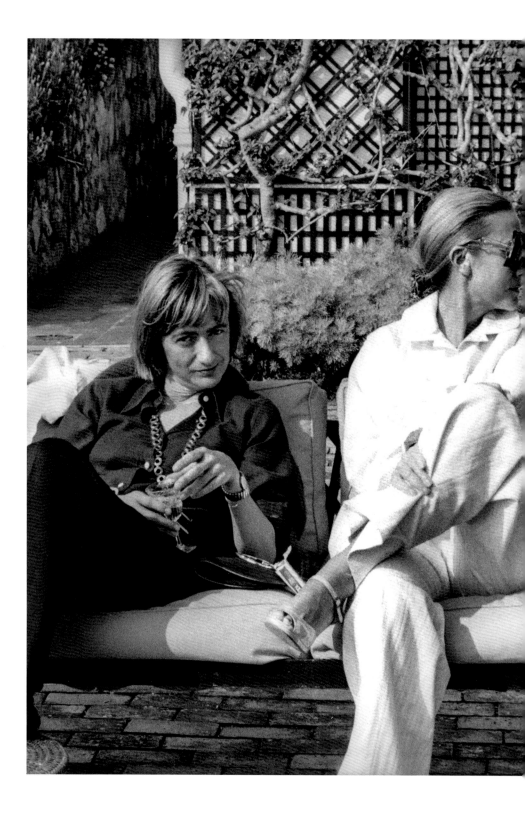

LEFT Françoise Sagan with Hélène Rochas—friends, though total opposites. Françoise was a legend, at home *chez* Lipp or at her house in the country, rather ill at ease, gracing the salons of the rich and famous. Hélène Rochas was *la Belle Madame Rochas*, one of the reigning queens of Paris *société*. She worshipped Yves and became an important client, giving luxurious dinners for him, to which she invited a mix of artists and followers.

Karl immediately recognized his own emotional and intellectual longings, and fell headlong in love with this brilliant *arriviste*. Jacques seized the opportunity and attached himself to Karl, who, like Andy, was asexual, as well as insecure about his rather chunky physique. Karl lived alone and neither drank nor took drugs, so was totally ripe for the picking. Jacques would seduce, inspire, and deceive Karl, who willingly paid for every caprice of his "lover," although he insisted that they never had sexual relations. Jacques elevated seduction and deception to a fine art, maliciously destroying many lives, and ultimately his own, when he succumbed to AIDS at the age of thirty-eight, with Karl at his side.

Before he met Jacques, Karl could be coaxed to join us for dinner at Club Sept on rue Sainte-Anne. After sipping his Coca Cola, he would retire early, leaving the rest of us to dance till dawn to the throbbing music of Guy Cuevas, the world's first DJ. Here, one could mix with the famous and infamous, the highest and lowest members of society, almost in secret. We were all becoming a close-knit family, united by the aura of The One: Yves Saint Laurent, who was seemingly unaware of his irresistible power of seduction. Yves had broken the mold, to transform fashion and dressing forever. He gathered a chosen few around him, then imposed his vision and style on the world.

FACING PAGE Paloma Picasso. Shy and reserved, her famous father having recently passed away, she was suddenly thrust into the limelight and later became a jewelry designer and glamorous fashion icon. We welcomed her, taking her to YSL Rive Gauche to shop for some new looks, and she joined us in September for the Venice Film Festival.
PAGES 66–67 The star-studded front row of friends at one of Yves's collections at rue Spontini in the early 1970s. From left, Hélène Rochas, Countess Lily Volpi, Betty Catroux, Silvia de Waldner, Olympia de Rothschild. Behind: Charlotte Aillaud, Kim d'Estainville, Clara Saint, François Catroux, the Lalannes, and Suzanne Luling.

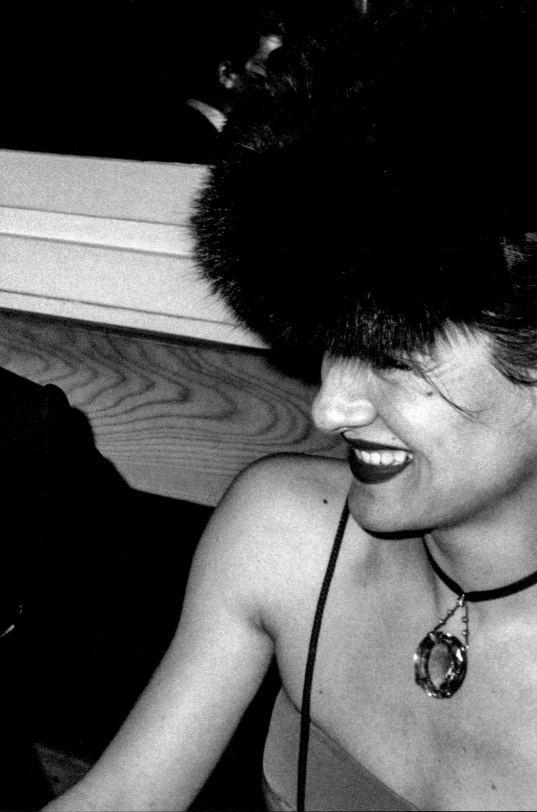

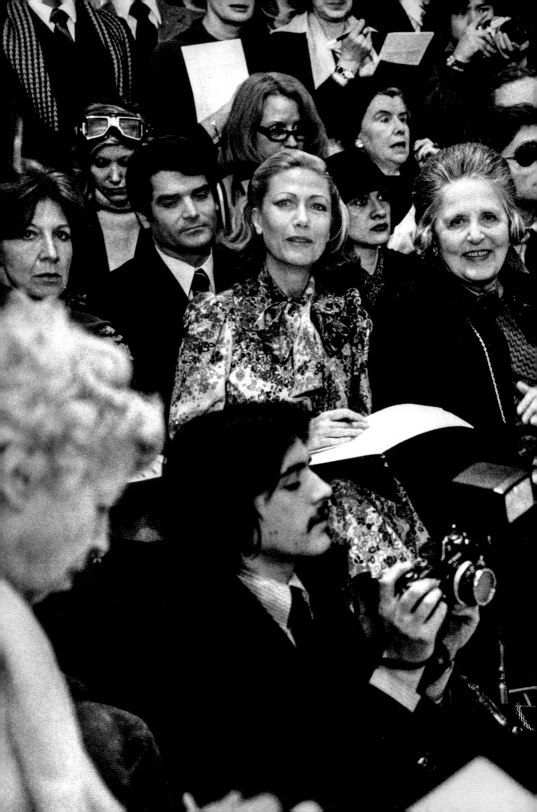

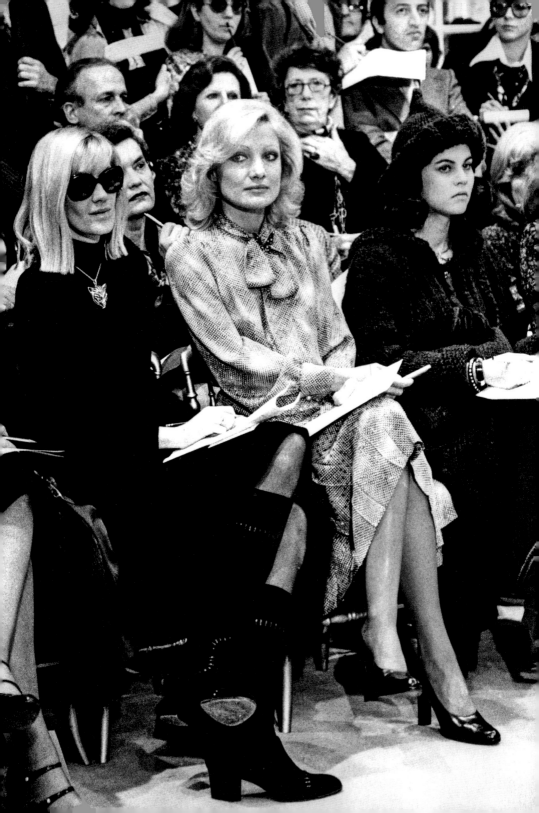

Loving Yves

In the summer, during the late 1960s, we would meet at place Vauban *chez* Yves and Pierre, usually with Betty and François Catroux, to indulge in a gossipy tea in the garden. This lasted until dusk, when we would dash home, change our clothes, then meet later for nights out with the gang. I often met Yves on rue Spontini, to view his collections in my role as an editor for *Glamour*. But more strikingly, it was our Paris nightlife that most inspired, liberated, and connected us all. Our first stop might be Chez Castel, on rue Princesse in Saint-Germain-des-Prés. We would descend the dark, narrow street, stopping at an inconspicuous door. After being scrutinized through a peephole, we were quickly admitted into the rarefied atmosphere. Our chicly dressed group passed muster everywhere we went: it was all about attitude.

Afterward, it was off to New Jimmy's, Regine's exclusive nightclub in Montparnasse, where Yves loved to dance, laugh, flirt, and make mischief. It was here he found Betty—Betty Saint before her marriage to François Catroux. Loulou was still in England, but would soon arrive to conquer Paris. Very late one night, in the dim light of the dance floor, I fell in love with Yves. Drawn together by an otherworldly connection, for some strange reason we kissed. And so began a boundless love affair of the mind and heart.

Pierre Bergé was YSL's guardian angel, a brilliant and possessive partner in business and at home. He allowed Yves occasional flights of fancy, but otherwise maintained a firm grip on him. I was very fortunate he accorded me a place in their lives, probably at first thanks to my Condé Nast status and Yves's homosexuality. Pierre soon learned that Yves was not bound by the merely physical, but was capable of passionate attachments to women without engaging in sexual relationships with them.

Yves admired my long, skinny body, my sense of spontaneity, and my sporty Françoise Hardy haircut. I reminded him of Brigitte, the sister he adored. Yves and I shared an outrageous and naughty complicity. We were constantly planning fanciful adventures (with or without Pierre's knowledge and approval), we spoke every day on the phone, and wrote to each other whenever we were apart.

FACING PAGE Yves in a pensive mood in his place Vauban garden.
PAGES 70 A smiling, relaxed Yves. His mother, Lucienne-Andrée, always near.
PAGES 71 Yves's sister Brigitte wearing wrapped and tied cotton safari pants.
PAGES 72–73 Because we were always up to no good, Yves dubbed me Mary Piggy. He wrote me many love letters, made drawings of me, and gave me clothes and so much affection. Our fetish animal was the snake.

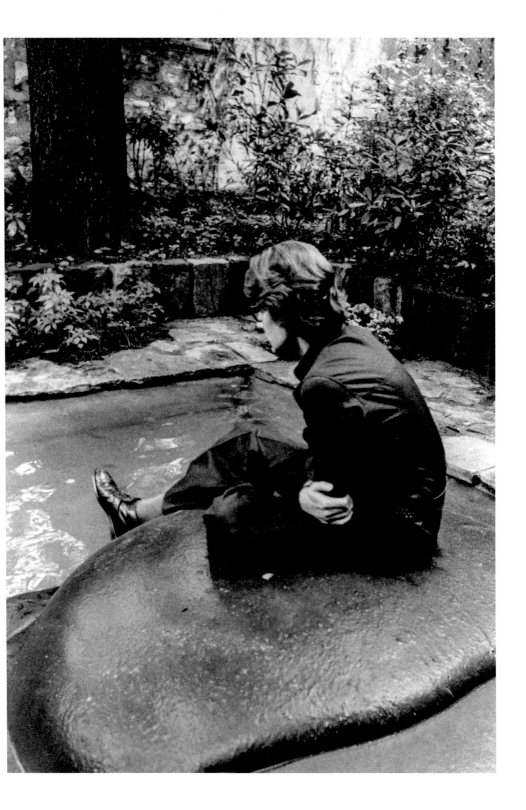

Piggy chérie

Je suis triste sans toi.
Reviens nous joindre. Si ce
n'est pas cette fois, une autre
fois. Ce serait merveilleux
de se retrouver tous ici à
Marrakech. Il fait un temps
sublime et nous attendons
Samedi prochain Loulou, Fer-
nando, Clara et Thadée et
Jacques Thual.
Je pense à toi très fort.
J'ai été ravi de te voir à
Paris et j'espère que tu
seras plus longtemps parmi
nous au Printemps avec
Peter.

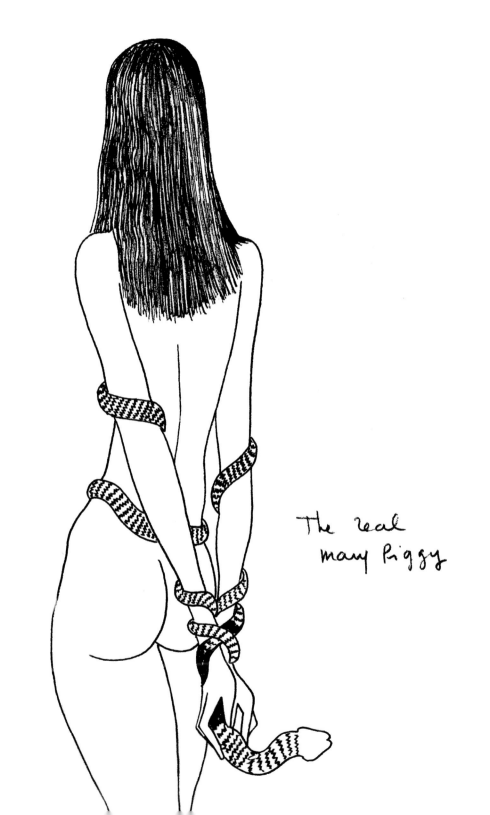

The real
mary Piggy

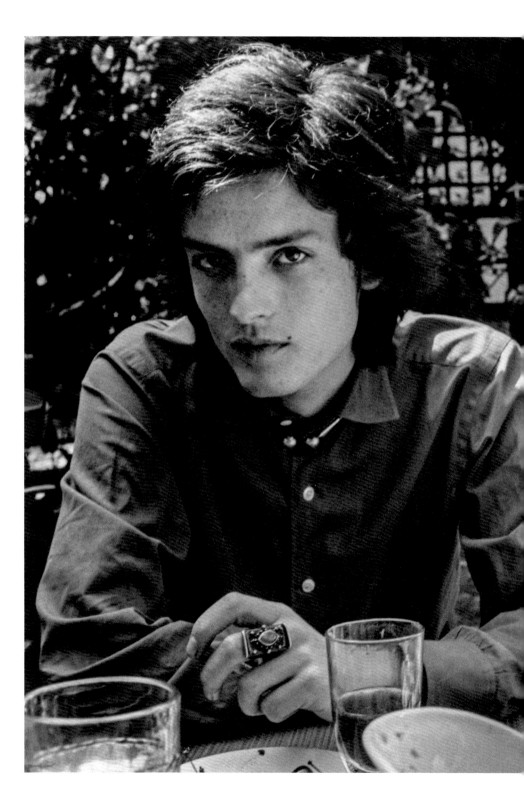

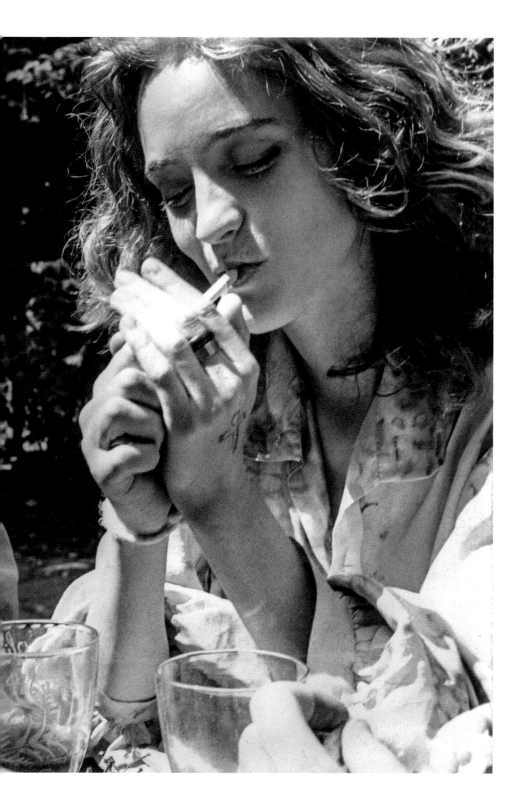

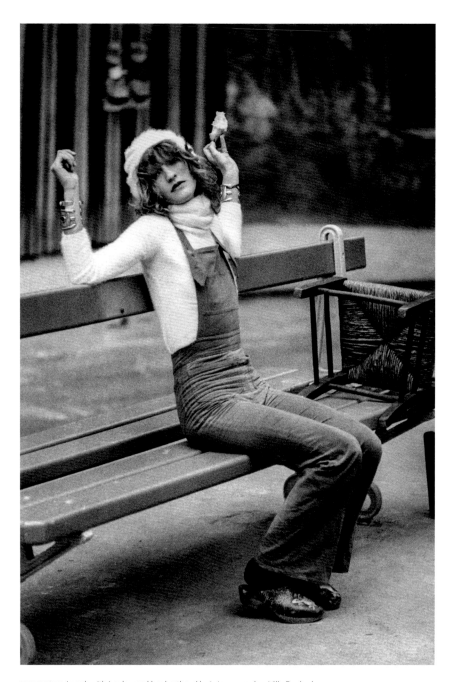

PAGES 74–75 Lunch with Loulou and her brother Alexis in my garden, Villa Boulard.
ABOVE AND FACING PAGE *Espiègle* (mischievous), Loulou was a true chameleon,
always acting out a role concocted to suit her mood or circumstances. Her taste
was so true, so original, she could create instant looks using whatever was at hand.
As a trusted assistant in his studio, she brought this instinctive talent to Yves,
who delighted in her elflike quirkiness. Here, lying on a fur rug, she quickly grabs
a few fur tails to make a headband.

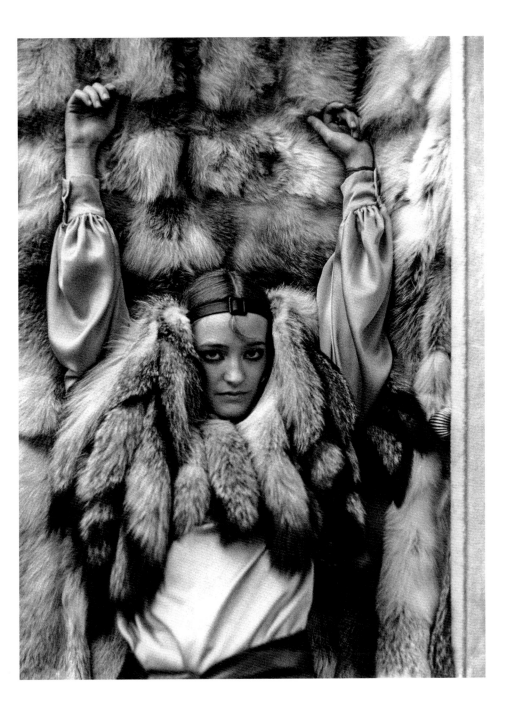

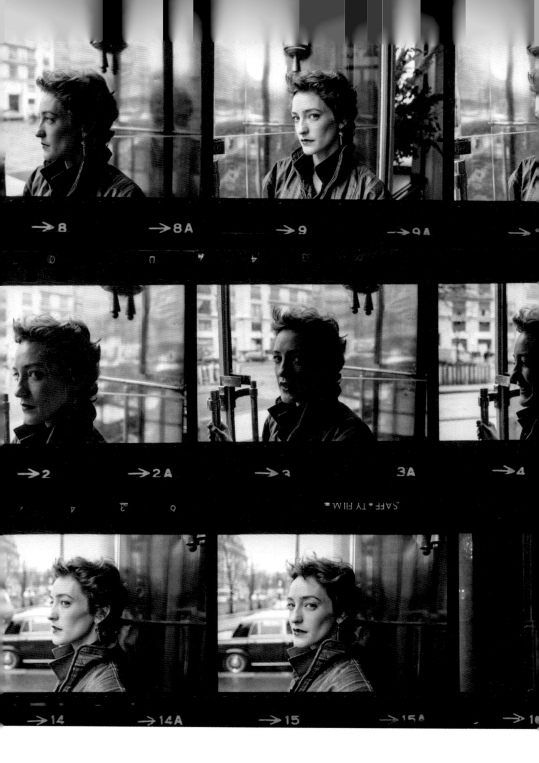

→ 8 →8A →9 →9A →

→2 →2A →3 3A →4

SAFE TY FILM

→14 →14A →15 →15A →

ABOVE A contact sheet, like a little film, captures some of Loulou's mercurial moods.

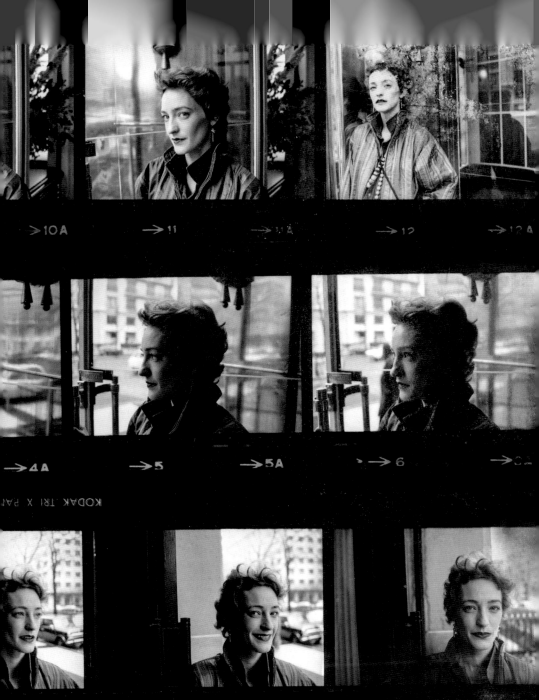

→10A →11 →11A →12 →12A

→4A →5 →5A →6 →6A

KODAK TRI X PAN

→16A →17 →17A →18 →18

Yves especially loved seeing me wearing his designs and showered me with both couture and ready-to-wear originals, most of which I have since offered to the Costume Institute at the Metropolitan Museum in New York and the YSL Museum in Paris. He squired me to chic Paris soirées where we would make a theatrical entrance. Sporting his black velvet tuxedo pantsuit was *"très shocking"* at a time when women were still dressed in stiff ball gowns. But it didn't matter, as I was on the arm of the master, a superstar who was beginning to shake up the world of fashion. Our friends and lifestyle merged gloriously. Looking back, it all seemed like a simple happy life…before fame and all it entailed changed everything forever.

Our intimate group evolved and grew with the advent of Loulou de la Falaise. Part of our Warhol connection, Louise, as she was known then, arrived at my Villa Boulard house in Montparnasse with Susan Bottomly (aka International Velvet, from the Warhol Factory), carrying all her belongings in a pillow case. Sylphlike and fey, fragile yet sweet, Loulou and her brother Alexis stayed a few weeks until he left for destinations unknown and she decamped *chez* Fernando Sanchez, who ultimately introduced her to Yves and Pierre.

I could write volumes about my enduring personal friendship with Loulou, from those first innocent days in the 1960s until our last lunch at the Flore so many years later. All that surfaces now are loving memories of her almost extraterrestrial presence; everything seemed to stop when she entered a room. With her wise-cracking, gamine demeanor, and her self-deprecating sense of mischievous fun, it was no wonder that Yves absolutely needed her by his side. Life was becoming increasingly stressful for him, as success and excess began drowning his spirit. Loulou's deep, throaty, derisive laugh, her total genius at creating chic from baubles and bits of fabric, her throwaway manner of wearing clothes like a gypsy pirate, her total honesty, and, yes, her innocence, had YSL enthralled. She was so intoxicating that people of every orientation were putty in her hands…Dearest Loulou! Just thinking of her still brings bittersweet tears to my eyes.

FACING PAGE Pierre Bergé with François Catroux. To understand Pierre, one would have had to live with or have personally experienced his towering intelligence and personality. He commanded attention. Demanded loyalty. Was a fierce friend. A genius. I loved him dearly.

80

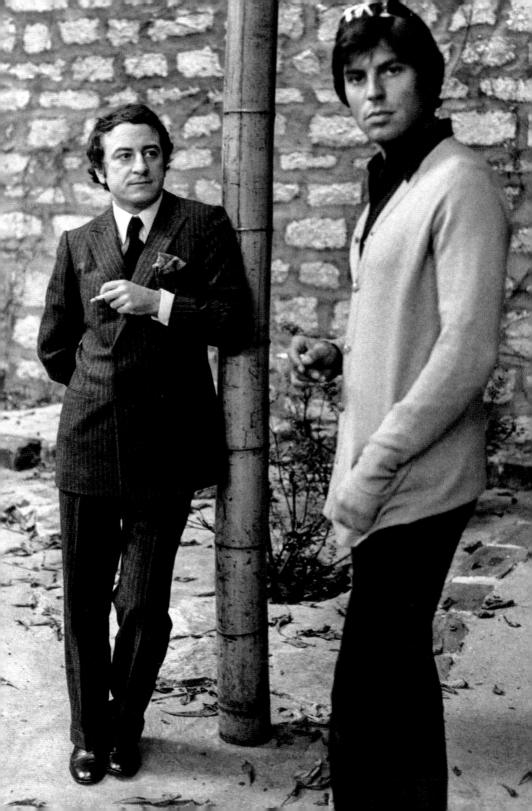

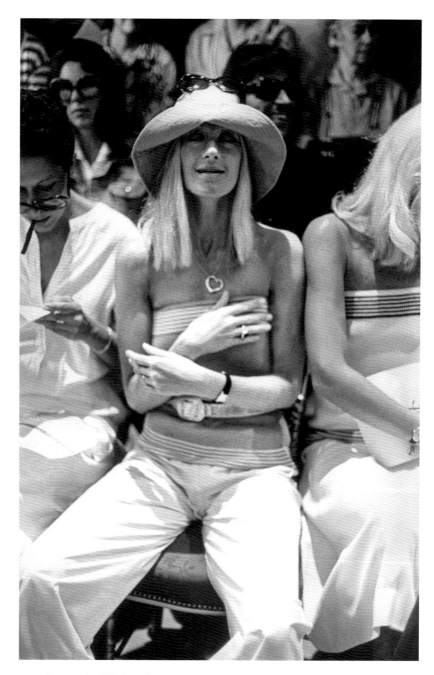

ABOVE Front row chez YSL, dressed in summer Rive Gauche:
Betty Catroux with Elsa Peretti on her right.

FACING PAGE If anyone was the total mirror of Yves, it was Betty. From
the moment they met, they were inseparable. She seemed to have come
from another planet. It was as if Yves had made a drawing of her, and
then breathed life into her to accompany him on otherworldly dream voyages.
Pierre, Yves, Betty, and François in the garden, place Vauban.

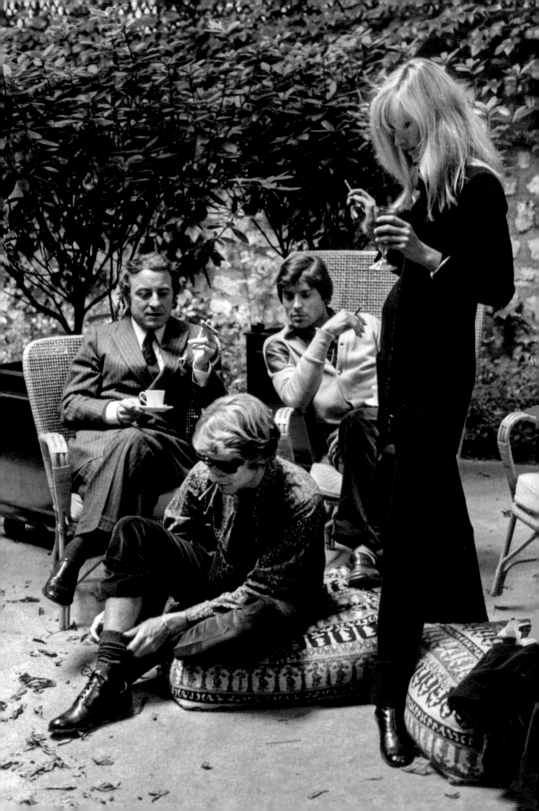

Muses

Lifestyles were rapidly evolving. Reigning society priestesses such as Marie-Hélène de Rothschild, Countess Lily Volpi, and Hélène Rochas eagerly sought opportunities to invite fascinating newcomers who aroused their curiosity. Mick and Bianca Jagger, Warhol, and Morrissey, along with their colorful entourages, were ushered into the most exclusive balls and dinner parties. Our crowd now gravitated between Paris, Saint-Tropez, Venice. In Saint-Moritz, we never missed ski lunches at the exclusive Corviglia Club or nights at Gunter Sachs' night club, Dracula, at Badrutt's Palace Hotel, where we cavorted with royals and rascals until dawn. Oh yes, we did occasionally get in some late afternoon skiing.

There were occasional visits to New York; *travail oblige* (real work did find its place in our very full pleasure-seeking schedules). Naturally, we hit Studio 54, then zipped out to Montauk to Andy's place or to photographer-artist Peter Beard's clifftop mill, where he held court for any and all who dropped in.

At that time, Paris feted Gainsbourg and Birkin. Their rue de Verneuil hideaway, which once hinted at taboo activities, has since become a cryptic shrine covered in bright graffiti. Their unabashed sexuality was proclaimed by Serge's explicit lyrics, which were charmingly rendered by Jane's high-pitched vocals. They were a couple unlike any other.

Long and lithe, Jane made a splash strolling the streets of Saint-Germain-des-Prés, lunching at Brasserie Lipp wearing an Agnès B white cotton jumpsuit, carrying her ubiquitous straw basket day and night. She graced the screen in cult movies *Blow Up* in 1966 and *La Piscine* in 1969, opposite Alain Delon and Romy Schneider, set in Saint-Tropez. However, life with Gainsbourg was tempestuous; his alcohol abuse contributed to their eventual break-up. Another British *égerie* (muse) was Charlotte Rampling, the perverse, dark heroine of Liliana Cavani's *The Night Porter*, who became a favorite of both Yves and Helmut Newton. We couldn't get enough of Charlotte at *Vogue*. I remember a shoot on location in Cannes with her and Helmut. The scenes remain vivid in my mind: laughing our way along the Croisette, and enjoying long, wine-filled lunches between shots.

FACING PAGE Diane von Furstenberg, all in black with piled-on jewelry, at the flower market in Geneva where we first met. She was still Diane Halfin, on her way to New York to marry her enigmatic fiancé, Prince Egon von Furstenberg. The rest is history.

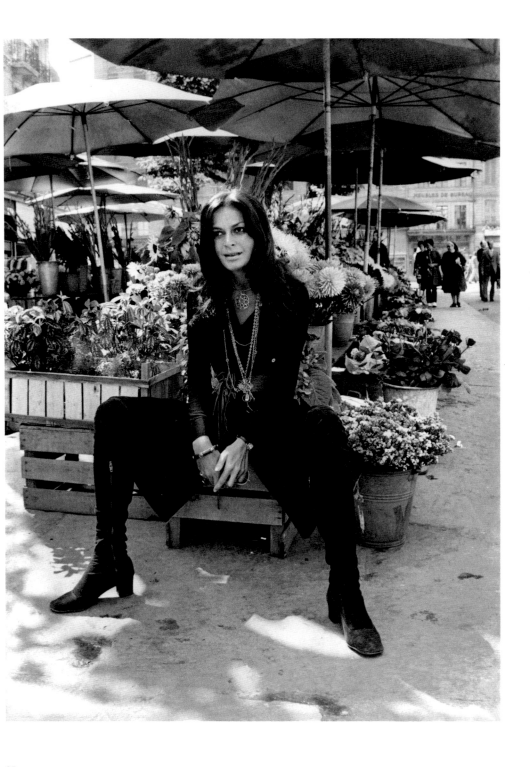

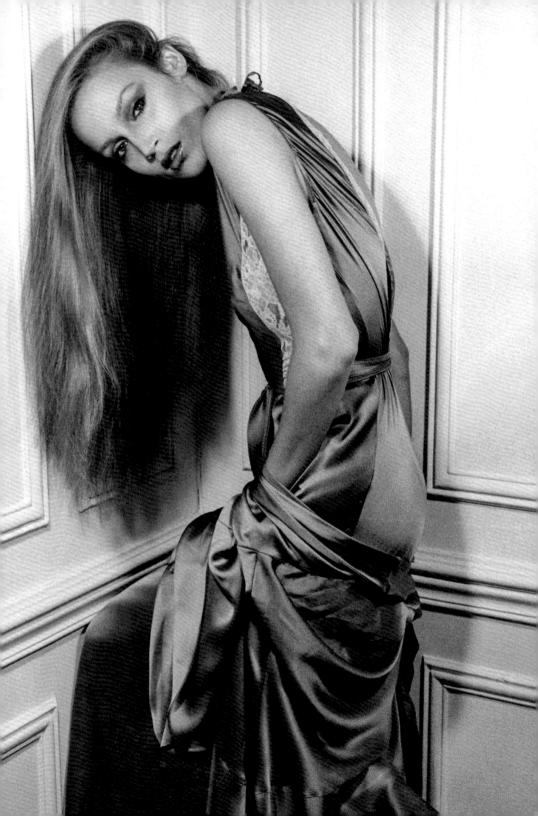

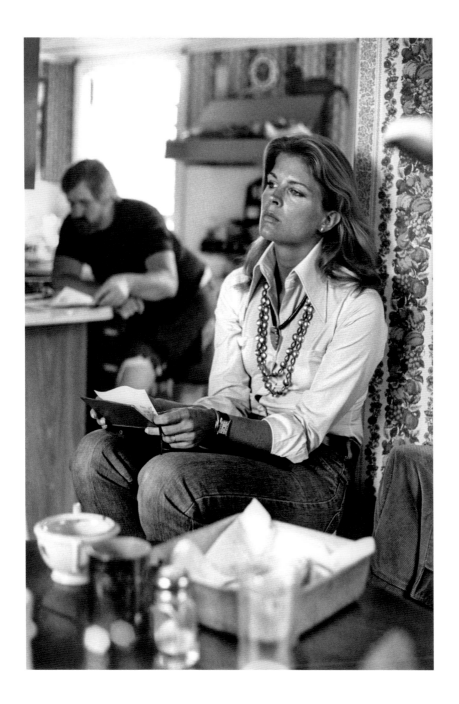

FACING PAGE I took this photo of Jerry Hall at Antonio Lopez's apartment
when she first arrived in Paris. I immediately sent it to Alex Liberman
at *Vogue*. She was charming, seductive, and fiercely ambitious.
ABOVE I photographed Candice Bergen *chez* Peter Beard in Montauk.
She was one of his many beautiful conquests.

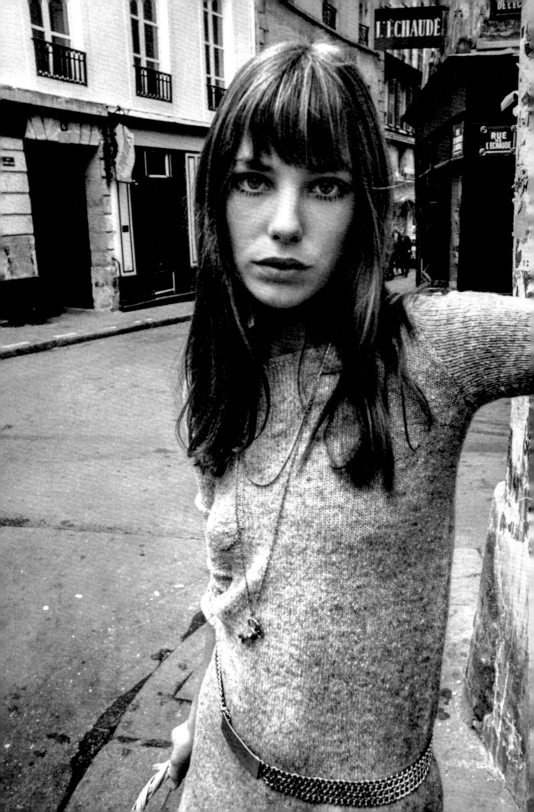

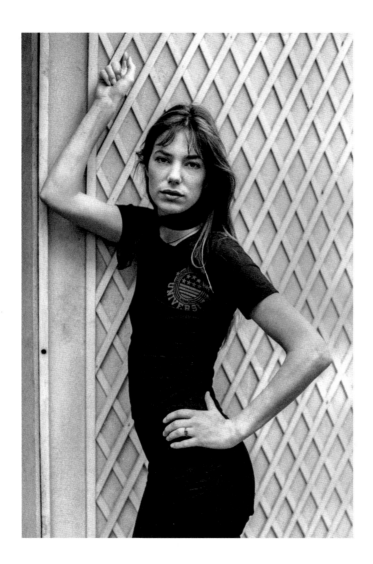

FACING PAGE At a moment when the French feminine ideal was a curvy Brigitte-Bardot-like blonde, Jane Birkin was a lanky bird, arriving on the scene in the 1960s to take Paris by storm. French girls copied her little-girl English accent and androgynous look. She could almost sing (when prompted by Gainsbourg), and most certainly could act.
ABOVE Jane's boyishly sexy look had slowly replaced Brigitte Bardot's girly Parisian style by the early 1970s.

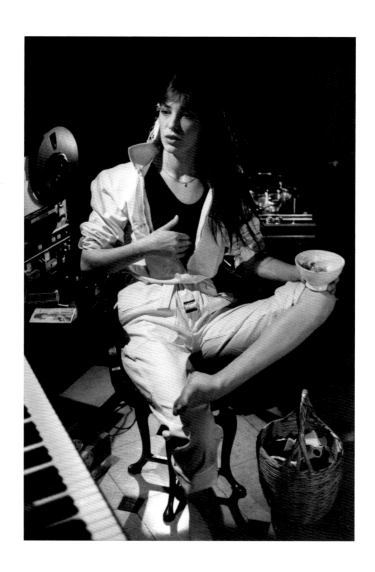

ABOVE Jane, wearing Agnès B's ubiquitous white jumpsuit,
sits at Serge Gainsbourg's piano, surrounded by his recording
paraphernalia in their black-painted salon, rue de Verneuil.
FACING PAGE I photographed ethereal Isabelle Adjani when
she first appeared on the Paris scene.

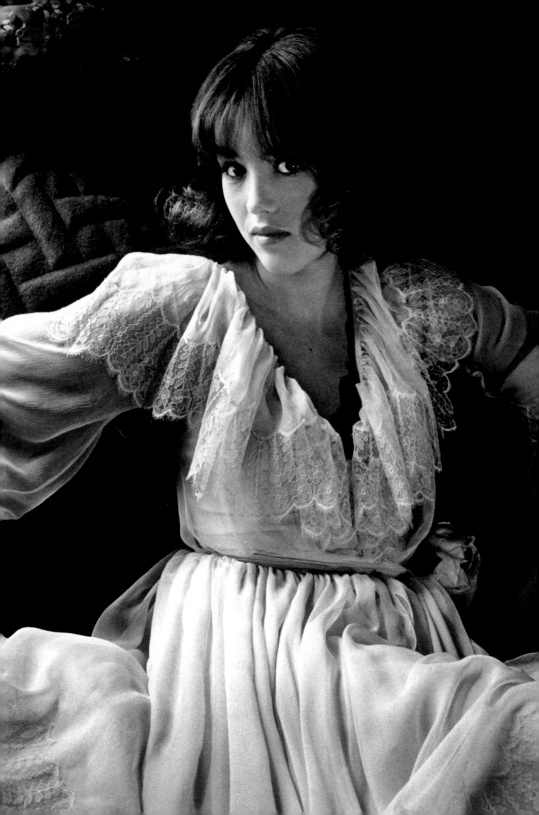

Flirts

In English, we described flirting as "to tease in a playful way."
In French, *"le flirt"* is explained as "a watercolor of love" (*"Le flirt est l'aquarelle de l'amour,"* Paul Bourget, 1883).

In the city of seduction, *le flirt* was the game. Life then was all about lighthearted, amorous adventure. We dallied and played, with no thoughts of tomorrow. Our friendships were free and affectionate.

In those not-so-innocent halcyon days there were true gentlemen roaming the pleasure palaces that my girl pals and I navigated. Glamorous, titled, wealthy, or broke, but ever so chic or just plain notorious, they were willing partners and playful prey.

Naughty or nice, they had manners, style, and panache. Like butterflies, we flitted, alighting for a brief fling or sizzling soirée. The word "playboy" was a badge of honor. Like naughty, dutiful girl scouts we joyfully vied among ourselves for a badge of conquest—for a moment in the limelight with any of them. It was truly a kind of game. I navigated the luxury world of playboys, movie stars, millionaires, and scoundrels. Among them Gunter Sachs, Peter Beard, and Philip Niarchos—to name but a few. My camera was a cool tool of seduction. What man doesn't love having his picture taken?

I found myself on a plane with Giovanni Volpi, flying to Argentina to meet the world-renowned racing driver Juan Manuel Fangio in Balcarce. As a racing-car fanatic and designer of Formula 1 racing cars, Giovanni's dream of filming a documentary on the life of Fangio was finally coming to fruition. Director Hugh Hudson and a film crew would be meeting us there to start shooting at Fangio's humble abode. We would later gather in Monte Carlo during the Grand Prix, where Fangio was king, to continue filming.

FACING PAGE Philip Niarchos, one of the sweetest men I have ever known. He was the eldest of the Niarchos brothers, son of the formidable Stavros, who kept a sharp eye on the doings of his sons. We skied in Saint-Moritz, cruised the Mediterranean on his father's yacht *Atlantis*, flew to Scotland for a weekend house party of game-shooting, lunched at the Hotel du Cap in Antibes, then spent a month with a gang of friends in Saint-Tropez where we never slept. As the eldest son of one of the most powerful Greeks in the world, Philip had yet to assume the reins (and the reign) of the Niarchos empire.

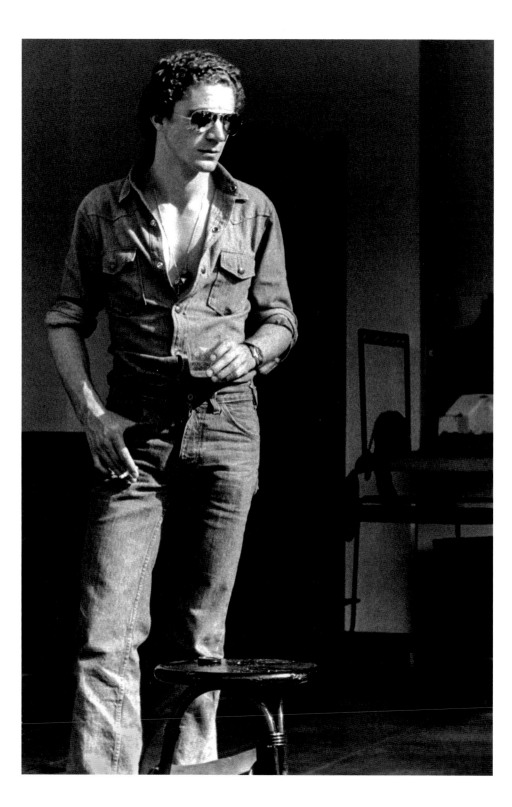

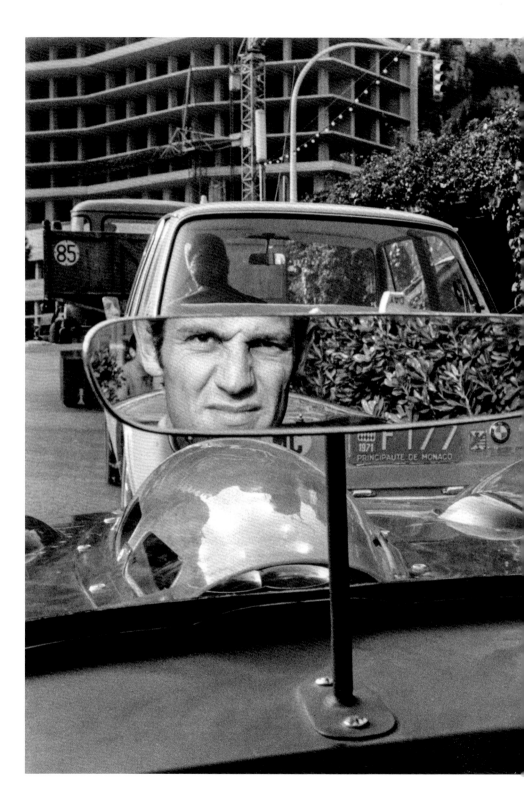

LEFT I snapped this photo of Giovanni Volpi as we drove the circuit of the Monaco Grand Prix in his Testarossa Ferrari before the race in the early 1970s. Later, we lunched at the Hotel de Paris with Fangio, accompanied by Jackie and Helen Stewart, as the Formula 1 race roared by outside.

Giovanni's love of adventure, sense of humor, generosity, and total elegance had me under his spell from the moment we met in Switzerland in the early 1970s. Enjoying the magnificence of the glamorous Volpi Ball and the film festival in Venice, where his name is ubiquitous, was a thrilling experience. Among many glamorous moments, my favorite was when he commandeered the *cucina* at his Roman *palazzo* to show me how to prepare perfect spaghetti: "It's the ingredients! Ripe *pomodori*, the finest olive oil," he would insist. "A sprinkle of grated *parmigiano, ed ecco!*" He created a world of unimaginable grandeur, and I loved being part of it.

Life unfolded effortlessly year after year, like a dream. It wasn't until the 1980s that everything changed. The horrendous AIDS epidemic, coupled with the dramatic consequences of drug use, had arrived on the scene to end our insouciant but not-so-innocent fun and games. Forever.

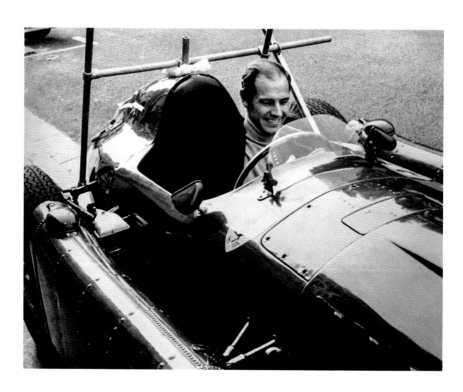

ABOVE Giovanni Volpi behind the wheel of the original Testarossa Ferrari.
FACING PAGE Giovanni overseeing the shooting of his documentary film *Fangio*, starring Juan Manuel Fangio—here with director Hugh Hudson on the streets of Monte Carlo during the Grand Prix.

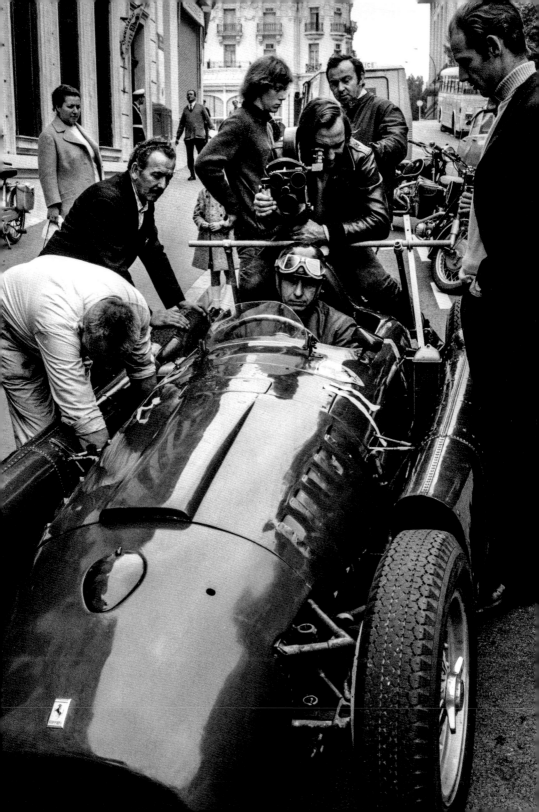

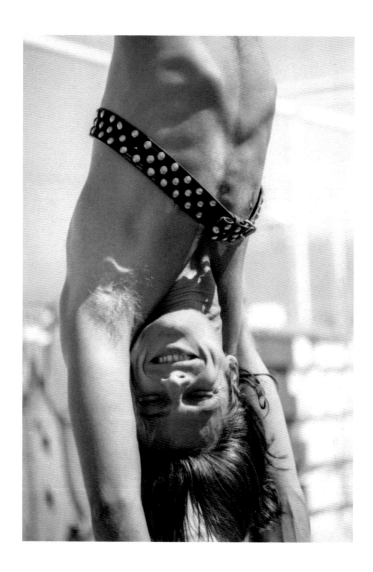

ABOVE AND FACING PAGE Hiram Keller, star of Fellini's *Satyricon*, was the most
beautiful human being I have ever laid eyes upon. I met him in the late 1960s,
when we spent a delicious weekend together in Mykonos. He was a sought-
after darling of the jet set, adored by one and all of us—all sexes included.
We all lived an insouciant *dolce vita* existence, flitting from one butterfly
to the next. My camera couldn't get enough of him.

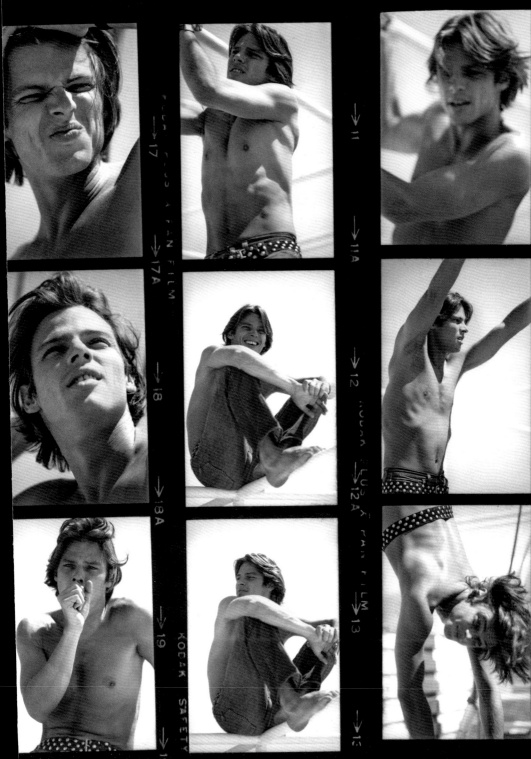

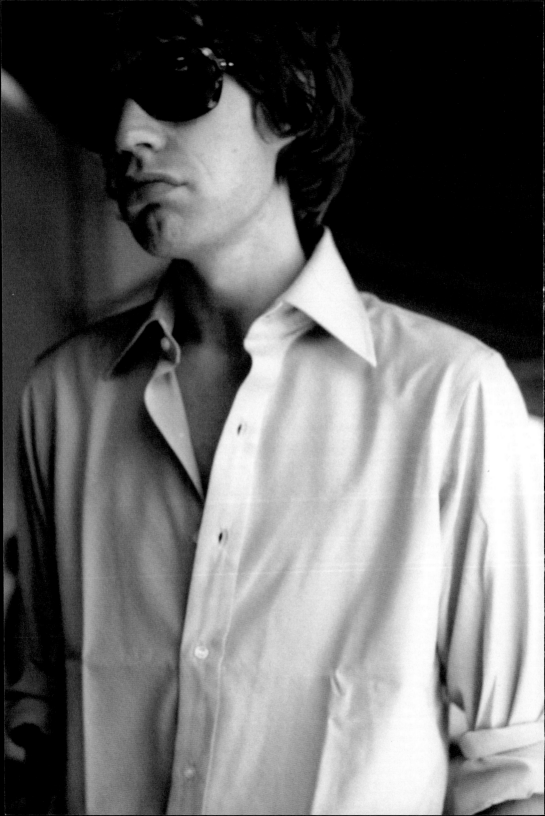

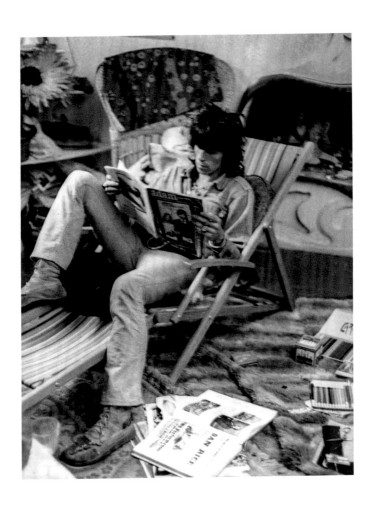

FACING PAGE AND ABOVE Mick and Keith in the 1960s…talk about seduction!
These notorious flirts win hands down. Afternoons, Keith would hang out at the
Catherine Harlé model agency to scope out new arrivals. The Stones were at all
the parties in Paris, and automatically became part of *la famille*. Remember, Paris
was small then. It was possible to move about without an onslaught of paparazzi.
I remember the night Mick met Jerry Hall at a dinner given by a Brazilian friend.
Jerry, wearing a see-through fishnet leotard, was an ambitious Texas filly who knew
exactly what she wanted, and made a bee-line toward Mick. He was a goner!

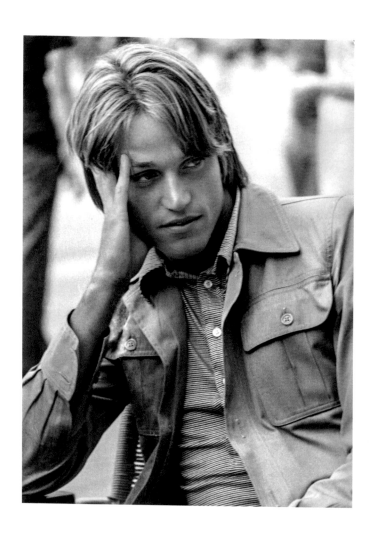

ABOVE Jay Johnson, beloved companion of Andy Warhol.
FACING PAGE British actor Michael York on the Lido, Venice, during
the film festival in the early 1970s. Talk about a head-turner.
Has there ever been a more beautiful profile? And that voice!

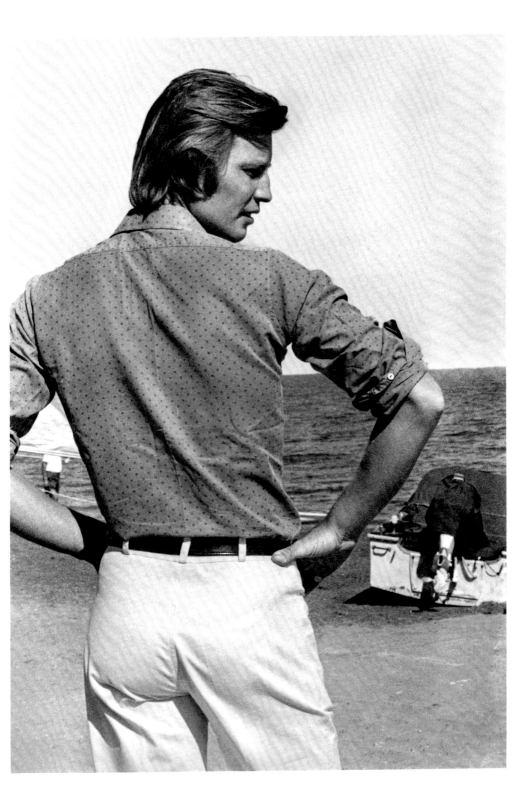

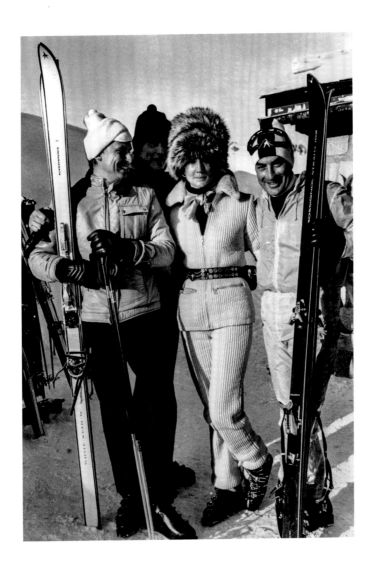

FACING PAGE Peter Kronig, ski instructor to the stars, in hip mufti.
They say every American girl dreams of flirting with a ski instructor.
I spent a lovely winter with Peter in Zermatt!
ABOVE Ski chic. Jacqueline de Ribes, handsomely accompanied,
outside the Corviglia Club, Saint-Moritz.

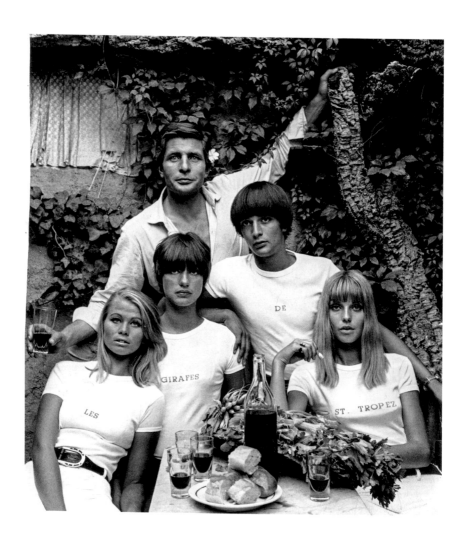

ABOVE AND FACING PAGE Gunter Sachs. There are not enough adjectives to describe this larger-than-life German playboy who was to become a life-changer for me. We met at L'Escale in Saint-Tropez in the mid-1960s. He ruled Saint-Tropez. I was perfunctorily added to his adoring tribe of beauties, both male and female. Wined and dined, whisked off to play the gaming tables at Monte Carlo. I was filmed naked on the beach covered in seaweed for his film *Les Girafes de Saint-Tropez*.

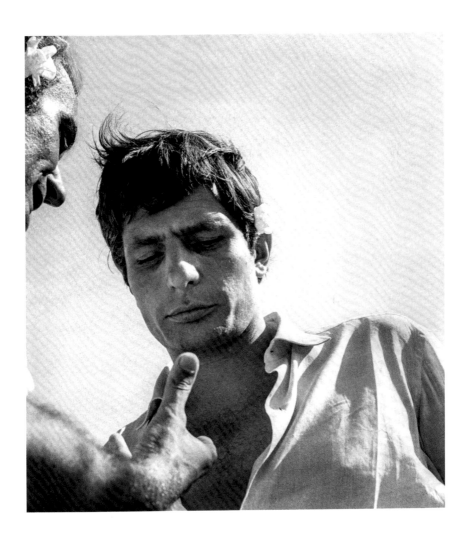

ABOVE *La Princesse Caroline de Monaco se marie?* To whom? To Philippe Junot. Princess Grace and the principality were shocked. He had no title! How did she meet him? Philippe was part of a merry band of bachelors who ruled Parisian nightlife. They met when Caroline was attending school in Paris,

away from the sharp, discerning eye of Princess Grace. Charm itself, he was
a descendant of General Jean-Andoche Junot, who served under Napoleon,
and whose family name figures on the Arc de Triomphe in Paris. I attended
their wedding in Monaco in 1978. Unfortunately, they divorced two years later.

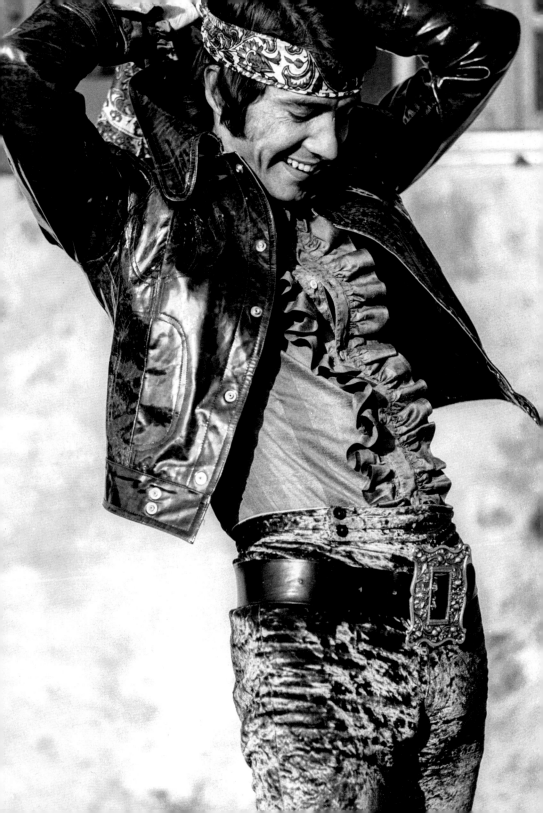

FACING PAGE In proud hippie plumage-velvet ruffles,
leather pirate belt, and headband, a friend, here in full display.
ABOVE And we danced the night away at the Papagayo in
Saint-Tropez in the early 1970s. From left: Egon von Furstenberg,
yours truly, Philip Niarchos, Florence Grinda.

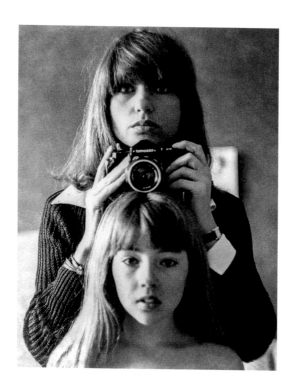

All photographs in this book were taken by Mary Russell except for those on the following pages: © Private collection: cover, p. 15, 16–17, 20–21, 48–49, 106, 111, back cover. Other photographs: p. 8: © Henry Clarke/Contributeur; p. 8: © Anthony Horth; p. 11: © Anthony Horth; pp. 12–13: © Bokelberg; p. 56: © Roxanne Lowitt. Every effort has been made to identify and list the photographers and rights holders of the images reproduced in this book. The publisher will be glad to correct any error or omission that may be brought to their attention in subsequent editions.

ABOVE My all-time favorite selfie, with my daughter Kitty.
FRONT COVER Caught with my Nikon on the streets of Paris.
BACK COVER Covering the Collections for *Vogue* in the 1970s, dressed by YSL Rive Gauche.